TREASURES OF THE

NATIONAL
GALLERY

LONDON

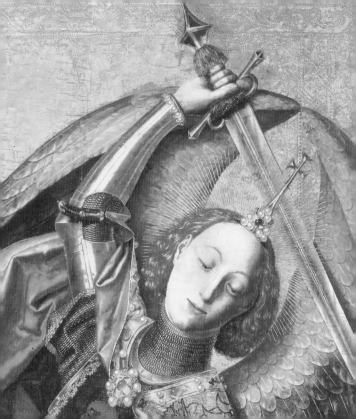

TREASURES OF THE

NATIONAL GALLERY

LONDON

INTRODUCTION BY NEIL MACGREGOR

TEXT BY ERIKA LANGMUIR

A TINY FOLIO™
THE NATIONAL GALLERY, LONDON
ABBEVILLE PRESS PUBLISHERS
NEW YORK LONDON

Contents

FOREWORD

In the National Gallery in London you can experience European painting as nowhere else in the world. It is not just that the collection is small and, as you will see in this book, contains many world-famous pictures. It is, above all, strikingly well balanced. In the space of an hour or so, you can walk from Giotto and early Renaissance Florence to Cézanne and the beginnings of Cubism in twentieth-century Paris. On the way, you will pass through every major European school of painting with works by the greatest masters—van Eyck, Leonardo and Caravaggio, Botticelli and Turner, Piero della Francesca, Rembrandt and van Gogh.

The pictures, all of them either bought by Parliament or given to the British people, were collected with two clear purposes in mind. One was to show through the best examples how the art of western Europe changed and developed. The collection does not privilege any particular country (and least of all Britain), but clearly demonstrates that pictures have always moved across frontiers, that in painting, at least, Europe has been united for many centuries. To walk, as in Trafalgar Square you can, directly from Titian to Rubens and then Velázquez, is to realise at once that the Italian, Flemish,

and Spanish artists together form one, indissoluble tradition. The collection is arranged to make these links as easy as possible to grasp.

But the collection's second purpose is even more important. Situated in the very heart of the city, open every day and free to all, its task is to provide to the working population of London and to the visitors of the world the pleasure of looking at some of the finest pictures ever made. Hundreds of thousands of Londoners visit regularly—both to get out of the rain and to see again a favourite picture, if only for a few minutes. The pictures in this book are part of their daily lives. But the collection is not just for Londoners: every year over four million visitors, from all over the world, come through our doors.

I hope that you will soon be one of them. But in the meantime, the book you are holding in your hand will give you a pretty good flavour of what you will find. Browse slowly, find your favourites, and then, if possible, come and look at the real things. They will not disappoint.

Neil MacGregor
Director

INTRODUCTION

The National Gallery, London, is small compared with other great European museums such as the Louvre, the Prado, and the Hermitage. It houses just over two thousand paintings, and—with the exception of a handful of objects bequeathed or borrowed for comparison or ornament—no works in other media. The Gallery's name sometimes confuses foreign visitors. It is not the national collection of British art, which can be found at the Tate Gallery on Millbank, London, but contains masterpieces from every school of western European painting, ranging in date from the mid-thirteenth century to the early decades of our own. All of the works in the collection are usually on view in the galleries.

Founded in 1824, a latecomer among European public collections, the National Gallery also differs from them by being based neither on a princely collection nor on the trophies of conquest. (The extensive Royal Collection, reflecting the taste of many outstanding royal patrons, is owned by the Crown and housed in the various royal palaces.) The National Gallery is not a state-run institution but an idiosyncratic mix of public and private funding, governed by a board of trustees whose members are appointed by the prime minister from a list

drawn up by the board, who elect their own chairman. The Gallery was established by an Act of Parliament with the purchase (funded by Austria's unexpected repayment of a war debt) of the private collection of John Julius Angerstein (1735–1823), a self-made financier, philanthropist, and collector born in Saint Petersburg. The majestic altarpiece by Sebastiano del Piombo, *The Raising of Lazarus* (page 108), now National Gallery Accession Number 1, was one of the outstanding works in this collection.

Among the people who had argued in favour of establishing a National Gallery were some who hoped that it would lead to a radical improvement in British painting and the flowering of a great national school; since 1768 artists had been able to obtain training at the Royal Academy but had no Old Master pictures to emulate. The majority of the advocates of a public gallery, however, thought that the aim was above all to provide the pleasure of pictures—"an ennobling enjoyment"— for those who could not themselves afford to own great paintings. The National Gallery was to be the private gallery of every person in the country, and all were to be encouraged to visit as often as they chose. Thus the Gallery's enduring policies of acquiring works of the highest quality and of admitting the public free of charge, as well as its vision of itself as an educational institution in the broadest sense of the word, all date from

its inception. Few, if any, European national collections have so high a proportion of their own citizens among their visitors, and none so many who come to look at their pictures on the way home or in a spare half hour, who attend lunchtime lectures every weekday or enrol in every study day. Even during the Second World War, when the pictures were removed for safekeeping to slate mines in Wales, popular demand obtained the return each month of one painting, the "Picture of the Month." Many grateful letters in the Gallery's archive testify to the success of this scheme in providing spiritual nourishment to men and women on leave from the armed forces and to civilians, in a city subjected to nightly bombing raids.

To Angerstein's pictures at the newly founded National Gallery (still housed, in 1824, in what had been his private residence, 100 Pall Mall) were added the paintings of Sir George Beaumont—John Constable's patron and one of the chief proponents of a national gallery. In 1823 Beaumont had promised his own collection to the nation, provided a suitable building could be found for the works' proper display and conservation. Peter Paul Rubens's *Autumn Landscape with a View of Het Steen in the Early Morning* (page 165) came from his collection and is the direct inspiration for Constable's famous summertime idyll of rural Suffolk, *The Hay-Wain*

(page 249), one of the "six-footers" on which the painter laboured during the long London winters. Exhibited in Paris in 1824, this picture in turn influenced French landscape artists; among them was Camille Corot, several of whose small studies, painted outdoors directly from the motif, are now assembled in the Gallery. Never exhibited in Corot's lifetime but sought after by other artists following his death, these works too proved influential on later generations of painters—not least being the Impressionists (many of whose works were donated to the Gallery by the twentieth-century textile magnate Samuel Courtauld).

Beaumont's generous gift was matched soon afterwards by the Reverend Holwell Carr, who pledged his pictures to the Gallery on the same conditions. His bequest includes, among others, Rembrandt's hauntingly beautiful *Woman Bathing in a Stream* (page 181)—one of a score of pictures by the Dutch master now admired in the Gallery by the five million or so visitors who come every year. Frank Auerbach, whose drawings and paintings after works by Rubens and Rembrandt were exhibited at the Gallery in 1995, is just one of the contemporary painters who find inspiration in the collection, affirming its continuing relevance and confirming the ideals of the Gallery's founders and its many benefactors.

In 1838 the National Gallery finally moved into purpose-built premises on Trafalgar Square, "the gangway

of London," a location accessible to the greatest number of Londoners and chosen for this reason, in preference to more salubrious sites. For the next thirty years the Gallery had to share William Wilkins's much-criticised building (not yet the "much-loved friend" it became in the 1980s) with the Royal Academy. By bequest, gift, and purchase the collection continued to grow rapidly, necessitating the enlargements of the 1870s by E. M. Barry, which comprise the whole of the block lying behind the east half of the original building. Barry's additions have just been restored to their original Victorian splendour, well suited to the eighteenth- and nineteenth-century pictures housed there. More galleries were added to the north of the portico in 1887; in 1911 the building was extended westwards. Rooms were added and courtyards roofed in the late 1920s, early 1930s, and in 1961. The North Galleries, providing an additional entrance from Orange Street, were completed in 1975 and will undergo remodelling in the near future.

The Sainsbury Wing—built through private donation and designed by the American architect Robert Venturi to house the earliest and most fragile paintings in the collection under optimal lighting and climatic conditions—was inaugurated in 1991, on the site of a bombed-out furniture store to the west of the main Gallery complex. In addition to the paintings on the upper

TITIAN (active c. 1506; died 1576).
The Death of Actaeon, c. 1565.
Oil on canvas, 71½ x 79¼ in. (178.4 x 198.1 cm).

(or main) floor, the wing contains a suite of galleries for temporary exhibitions, a theatre for lectures and events, and the Micro Gallery, an innovative computer information room for use by the general public.

The history of the ways the collection has been displayed vividly reflects changes in taste and in the philosophical underpinnings of art history and museum design in England and beyond. Until 1991 the pictures were hung mainly by national and local "schools." A guidebook of 1908 describes a school as "a group of artists working under the influence of a leader—a painter who has brought some new view of art into the world." But the concept has also been defined according to notions of "national character"—notions that are usually anachronistic, for the map of Europe in earlier centuries did not correspond to the nation-state divisions of modern Europe. Since 1991 the pictures on the main floor have been hung chronologically in four wings: Painting from 1260 to 1510 in the Sainsbury Wing; Painting from 1510 to 1600 in the West Wing; Painting from 1600 to 1700 in the North Wing; and Painting from 1700 to 1900 in the East Wing, divisions corresponding to the four chapters of this book. In 1997 the National Gallery acquired loans from the Tate of important works dating from before 1900, by Paul Cézanne, Edgar Degas, Paul Gauguin, Vincent van Gogh, and Claude Monet. Pictures

painted after that year—mainly by Henri Matisse, Pablo Picasso, Odilon Redon, Pierre-Auguste Renoir, and Edouard Vuillard—were ceded on loan to the Tate.

The public also has access to the more densely hung lower floor in the main building, which houses the less significant works in the collection. (There is a fairly continuous traffic of pictures between the main and lower floors as loans are made to other institutions, reputations rise and fall, attributions change, and the qualities of paintings are revealed through cleaning or restoration.) The great advantage of the main floor's pioneering hang is that it reveals, perhaps for the first time in a gallery, the international character of European art and culture, as painters, pictures, patrons, ideas, and inventions travelled—faster than we sometimes imagine. It is this history of persistent tradition and recurrent innovation that the uniquely eclectic nature of the National Gallery collection enables us to trace, through some of the finest pictures ever painted.

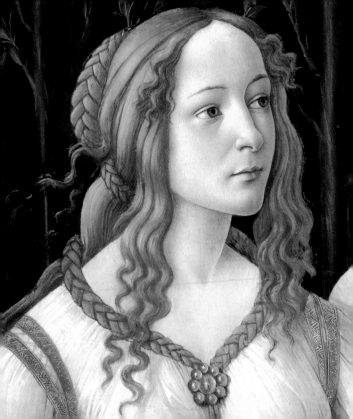

THE SAINSBURY WING:
PAINTING FROM 1260 TO 1510

The Sainsbury Wing contains Early Renaissance pictures from north and south of the Alps, painted between 1260 and 1510, when Europe was largely a patchwork of city-states and principalities, most with allegiances to feudal lords, including kings and the Holy Roman Emperor. Courts—those great consumers of art—communicated with each other and often had interests in more than one part of the Continent.

All western European institutions recognised the spiritual authority of the pope, who was bishop of Rome and head of the Catholic (that is, universal) Church, for which the greatest number of works of art were created. In the same period local art traditions were forged as well, which were promoted through craft associations and family ties. Most of the rooms in the Sainsbury Wing are devoted to painting from Italian centres, reflecting the bias of the collection, and this in turn is reflected in the wing's architectural style, which evokes the cool interiors of the Florentine Renaissance.

Most of the pictures are devotional: either church altarpieces or altarpiece fragments—such as Masaccio's imposing *Virgin and Child* (page 34), the central panel

from his 1426 Pisa Altarpiece, and Piero della Francesca's early morning *Baptism of Christ* of the 1450s (page 46)—or images intended to aid pious meditation and prayer at home or while travelling. Notable examples of portable altarpieces are Duccio's precious triptych of around 1315, *The Virgin and Child with Saints Dominic and Aurea* (page 24), almost certainly commissioned by a cardinal of Ostia who was also a member of the Dominican Order, and the sumptuous *Wilton Diptych* (page 26), made in the 1390s by an unknown workshop for the English King Richard II, whose portrait it includes. The fact that this miniature folding altar was painted in tempera and lavishly embellished with gold leaf (techniques associated with Italy) on oak (a painting support native to northern Europe) testifies to the international character of court art.

If these objects also demonstrate the fine line between piety and a love of luxury, the Sicilian Antonello da Messina's little *Saint Jerome in His Study* (page 63) bears witness to the growing appreciation later in the period for more purely pictorial skill. Painted in oils around 1475, probably in Venice and for a Venetian collector, this picture eschews the semblance of enamelled and bejewelled solid gold for the illusion of reality: a view into a three-dimensional interior, bathed in natural light, with glimpses of infinite landscapes beyond.

Of the nonreligious pictures in the Sainsbury Wing, the majority are portraits. One of the topics that can be

followed here is the evolution of lifelike portraiture, a type of painting that, like the use of oils, was pioneered in the Netherlands. The best-known Netherlandish example, Jan van Eyck's 1434 portrait of a merchant from Lucca and his wife, *The Arnolfini Portrait* (page 37), is also an object lesson in the techniques emulated by Antonello: the use of slow-drying and translucent oils to represent the fall of light on, and through, different materials, from the silky hairs of a lapdog to the crystal beads of a rosary.

Bartolomé Bermejo's *Saint Michael Triumphant over the Devil with the Donor Antonio Juan* (page 55), acquired in 1995, combines all the themes we have been tracing: a large-scale altarpiece painted in 1468 for the church of San Miguel in Tous in the province of Valencia, executed in oils in a Netherlandish style by a Spanish artist, it includes a minutely realistic portrait of the donor venerating the saint.

Another genre represented in the Sainsbury Wing is Italian secular domestic decoration, based on vernacular literature and history or reflecting a new interest in Graeco-Roman antiquity. Paolo Uccello's *Battle of San Romano* of the 1450s (page 42), one of three panels once set in the wall of a room in the Palazzo Medici in Florence, simultaneously celebrates an actual Florentine victory and Uccello's expertise in the new science of linear perspective, while replicating the poetic charm of northern tapestry. Sandro Botticelli's *Venus and Mars* (page 66),

with its reclining figures adapted to the oblong panel's original function as the backboard of a bench or chest, must have formed part of a bridal suite of furniture. Its timeless message, "love conquers war," is leavened with wit: neither the buzzing of wasps nor the conch shell blown in his ear can wake Mars, exhausted with lovemaking.

A visit to the Sainsbury Wing culminates in the graceful early work of Raphael and in two works executed in Milan by Leonardo da Vinci: the famous cartoon, a full-scale drawing of *The Virgin and Child with Saint Anne and Saint John the Baptist* (page 74), and the second version of *"The Virgin of the Rocks"* (page 75; the earlier version is in the Louvre, in Paris). Their ample rhythms and idealised forms mark the end of Early, and the beginning of High, Renaissance painting, on view in the West Wing.

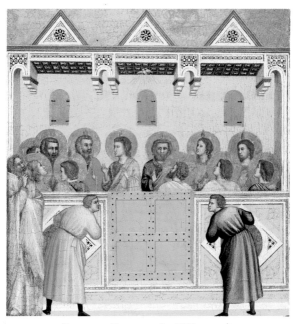

GIOTTO DI BONDONE (1266/67–1337).
Pentecost, c. 1306–12. Tempera on poplar,
18 x 17¼ in. (45.5 x 44 cm).

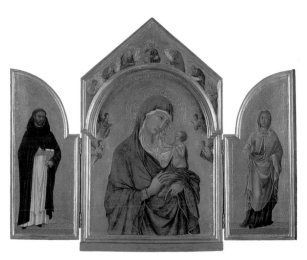

DUCCIO (active by 1278; died 1318/19).
The Virgin and Child with Saints Dominic and Aurea, c. 1315.
Tempera on poplar, central panel: 17 x 13½ in. (42.5 x
34.4 cm), side panels: 16½ x 6½ in. (42 x 16.5 cm), each.

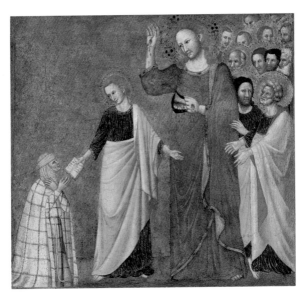

MASTER OF THE BLESSED CLARE (active mid-14th century).
Vision of the Blessed Clare of Rimini, c. 1340.
Tempera on wood, 22 x 24 in. (55.9 x 61 cm).

ENGLISH OR FRENCH SCHOOL(?).
The Wilton Diptych, c. 1395–99.
Egg tempera on oak, each panel: 20⅞ x 15 in. (53 x 37 cm).

GENTILE DA FABRIANO (c. 1385–1427).
The Madonna and Child with Angels (The Quaratesi Madonna),
1425. Tempera on poplar, 55 x 32¾ in. (139.9 x 83 cm).

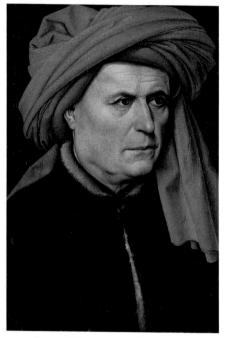

ROBERT CAMPIN (1378/79–1444).
A Man and *A Woman,* probably c. 1430.
Oil and tempera on oak, 16 x 11 in. (40.7 x 27.9 cm), each.

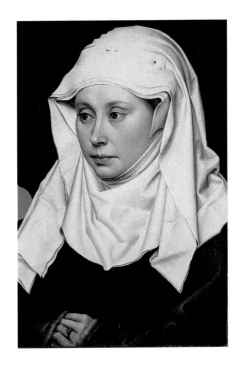

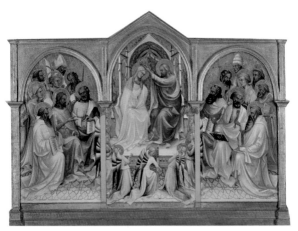

LORENZO MONACO (before 1372–1422 or later).
The Coronation of the Virgin with Adoring Saints, probably
1407–9. Tempera on poplar, centre panel: 85½ x 45¼ in.
(217 x 115 cm); left panel: 71½ x 41⅜ in. (181.5 x 105 cm);
right panel: 70½ x 40 in. (179 x 101.5 cm).

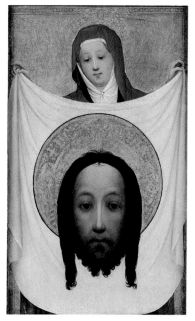

Master of Saint Veronica (active early 15th century).
Saint Veronica with the Sudarium, c. 1420.
Oil on walnut, 17⅜ x 13¼ in. (44.2 x 33.7 cm).

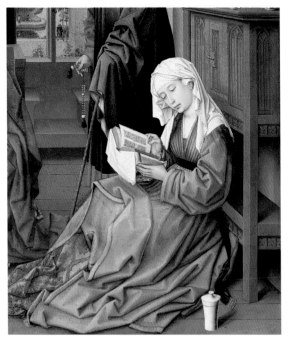

ROGIER VAN DER WEYDEN (c. 1399–1464).
The Magdalen Reading, probably c. 1435.
Oil on mahogany, 24¼ x 21½ in. (61.6 x 54.6 cm).

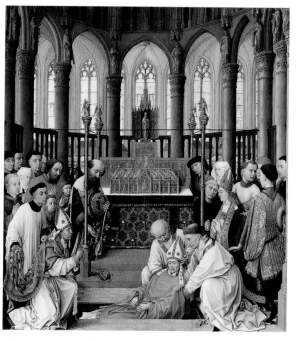

ROGIER VAN DER WEYDEN (c. 1399–1464) AND WORKSHOP.
The Exhumation of Saint Hubert, c. 1440.
Oil on oak, 34⅝ x 31¾ in. (87.9 x 80.6 cm).

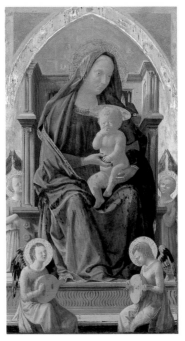

MASACCIO (1401–probably 1428).
The Virgin and Child, 1426.
Tempera on poplar, 53⅜ x 28¾ in. (135.5 x 73 cm).

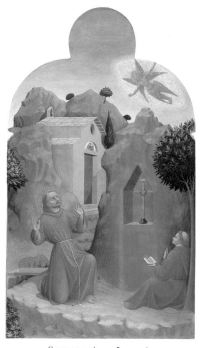

SASSETTA (1392?–1450).
The Stigmatisation of Saint Francis, 1437–44.
Tempera on poplar, 34¼ x 20¾ in. (87.5 x 52.5 cm).

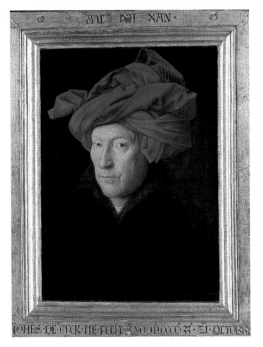

JAN VAN EYCK (active by 1422; died 1441).
A Man in a Turban, 1433.
Oil on oak, 13⅛ x 10⅛ in. (33.3 x 25.8 cm).

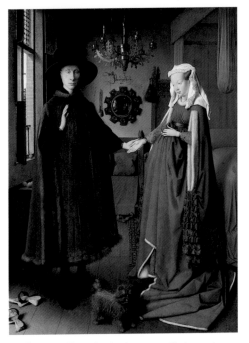

JAN VAN EYCK (active by 1422; died 1441).
The Arnolfini Portrait, 1434.
Oil on oak, 32¼ x 23½ in. (81.8 x 59.7 cm).

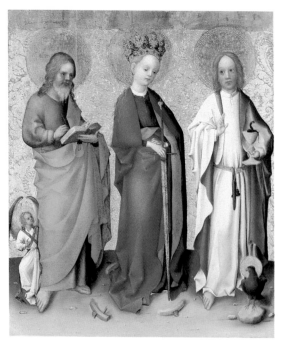

STEPHAN LOCHNER (active by 1442; died 1451).
Saints Matthew, Catherine of Alexandria and John the Evangelist,
c. 1445. Oil on oak, 27 x 22⅞ in. (68.6 x 58.1 cm).

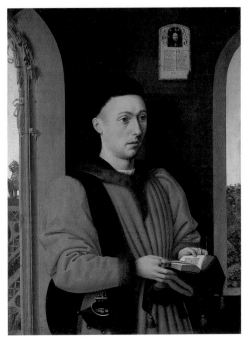

PETRUS CHRISTUS (active by 1444; died 1475/76).
Portrait of a Young Man, 1450–60.
Oil on oak, 14 x 10⅜ in. (35.5 x 26.3 cm).

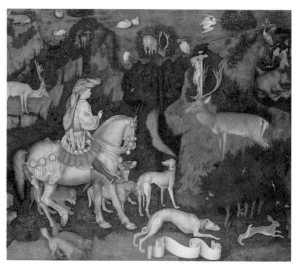

PISANELLO (c. 1395–probably 1455).
The Vision of Saint Eustace, mid-15th century.
Tempera on wood, 21½ x 25¾ in. (54.5 x 65.5 cm).

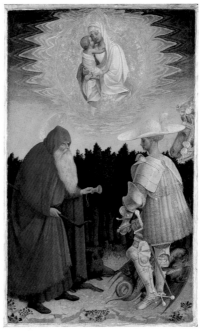

PISANELLO (c. 1395–probably 1455).
The Virgin and Child with Saint George and
Saint Anthony Abbot, mid-15th century.
Tempera on poplar, 18½ x 11½ in. (47 x 29.2 cm).

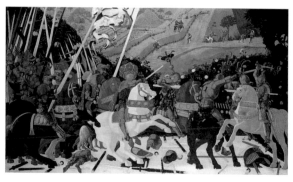

PAOLO UCCELLO (1397–1475).
The Battle of San Romano, probably c. 1450–60.
Tempera on poplar, 71⅝ x 126 in. (182 x 320 cm).

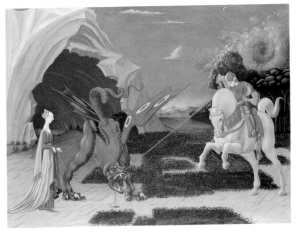

PAOLO UCCELLO (1397–1475).
Saint George and the Dragon, c. 1460.
Oil on canvas, 22¼ x 29⅛ in. (56.5 x 74 cm).

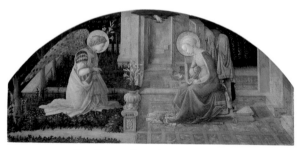

Fra Filippo Lippi (c. 1406–1469).
The Annunciation, late 1450s.
Tempera on wood, 27 x 59⅞ in. (68.5 x 152 cm).

GIOVANNI DI PAOLO (active by 1417; died 1482).
Saint John the Baptist Retiring to the Desert, probably c. 1453.
Tempera on poplar, 12¼ x 15¼ in. (31.1 x 38.8 cm).

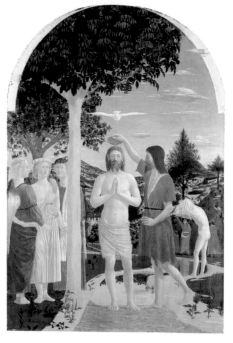

Piero della Francesca (c. 1415/20–1492).
The Baptism of Christ, 1450s.
Tempera on poplar, 65¾ x 45¾ in. (167 x 116 cm).

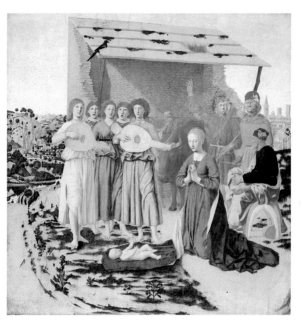

PIERO DELLA FRANCESCA (c. 1415/20–1492).
The Nativity, 1470–75.
Oil on poplar, 48⅝ x 48¼ in. (124.4 x 122.6 cm).

DIERIC BOUTS (1400?–1475).
The Entombment, probably 1450s.
Glue size on linen, 35½ x 29¼ in. (90.2 x 74.3 cm).

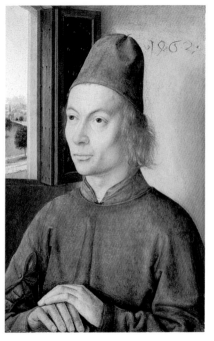

DIERIC BOUTS (1400?–1475).
Portrait of a Man, 1462.
Oil on oak, 12½ x 8 in. (31.8 x 20.3 cm).

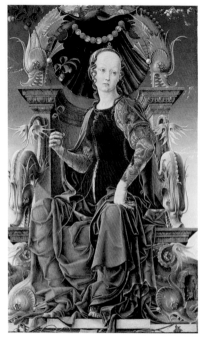

COSIMO TURA (before 1431–1495).
An Allegorical Figure, probably 1455–60.
Oil on poplar, 45¾ x 28 in. (116.2 x 71.1 cm).

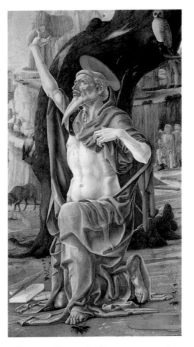

Cosimo Tura (before 1431–1495).
Saint Jerome, probably c. 1470.
Oil and tempera on poplar, 39¾ x 22½ in. (101 x 57.2 cm).

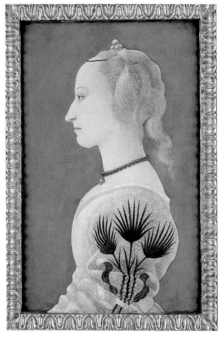

ALESSO BALDOVINETTI (c. 1426–1499).
Portrait of a Lady in Yellow, probably 1465.
Tempera and oil on wood, 24¾ x 16 in. (62.9 x 40.6 cm).

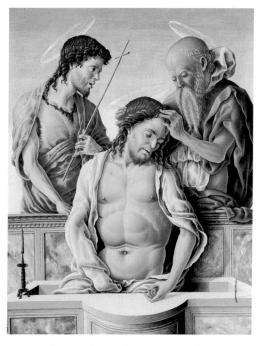

MARCO ZOPPO (c. 1432–c. 1478).
The Dead Christ Supported by Saints, c. 1465.
Tempera on wood, 10⅜ x 8¼ in. (26.4 x 21 cm).

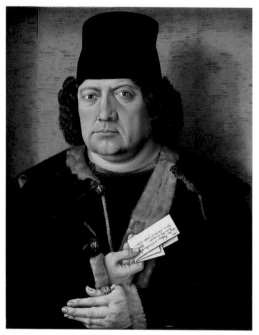

MASTER OF THE MORNAUER PORTRAIT
(probably active c. 1460–88).
Portrait of Alexander Mornauer, c. 1464–88.
Oil on wood, 17¾ x 15¼ in. (45.2 x 38.7 cm).

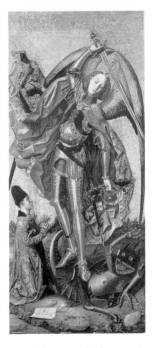

BARTOLOMÉ BERMEJO (active c. 1460–98).
*Saint Michael Triumphant over the Devil with the
Donor Antonio Juan*, c. 1468.
Oil and gold on wood, 70½ x 32¼ in. (179 x 81.9 cm).

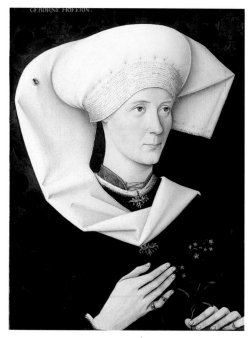

GEBORNE HOFERIN.

UNKNOWN SWABIAN ARTIST.
Portrait of a Woman of the Hofer Family, c. 1470.
Oil on silver fir, 21⅛ x 16 in. (53.7 x 40.8 cm).

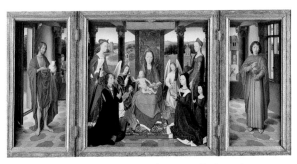

HANS MEMLING (active by 1465; died 1494).
*The Virgin and Child with Saints and Donors
(The Donne Triptych),* probably c. 1475.
Oil on oak, 28 x 51¾ in. (71.1 x 131.5 cm), overall.

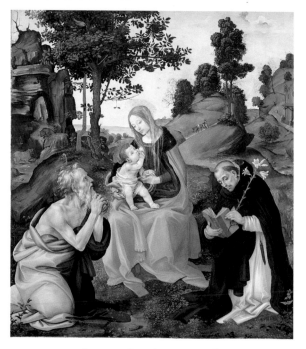

FILIPPINO LIPPI (c. 1457–1504).
The Virgin and Child with Saints Jerome and Dominic, c. 1485.
Oil and tempera on poplar, 80 x 73¼ in. (203.2 x 186.1 cm).

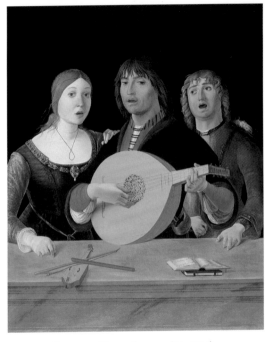

LORENZO COSTA (c. 1459/60–1535).
A Concert, c. 1485–95.
Oil on poplar, 37½ x 29¾ in. (95.3 x 75.6 cm).

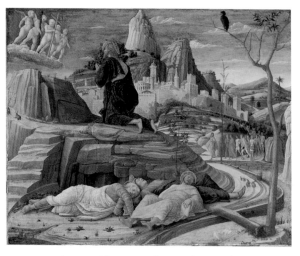

ANDREA MANTEGNA (c. 1430/31–1506).
The Agony in the Garden, c. 1460.
Tempera on wood, 24¾ x 31½ in. (62.9 x 80 cm).

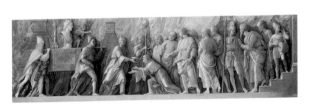

Andrea Mantegna (c. 1430/31–1506).
The Introduction of the Cult of Cybele at Rome, 1505–6.
Glue size on linen, 29 x 105½ in. (73.7 x 268 cm).

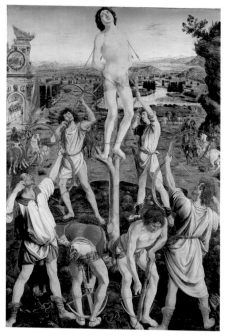

ANTONIO (c. 1432–1498) AND PIERO
(c. 1441–before 1496) DEL POLLAIUOLO.
The Martyrdom of Saint Sebastian, completed 1475.
Oil on poplar, 114¾ x 79¾ in. (291.5 x 202.6 cm).

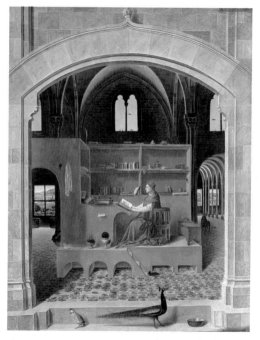

Antonello da Messina (active by 1456; died 1479).
Saint Jerome in His Study, c. 1475.
Oil on limewood, 18 x 14¼ in. (45.7 x 36.2 cm).

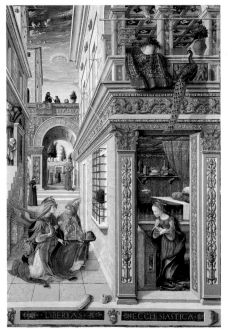

CARLO CRIVELLI (c. 1430/35–c. 1494).
The Annunciation, with Saint Emidius, 1486.
Tempera and oil on canvas, transferred from wood,
81½ x 57¾ in. (207 x 146.7 cm).

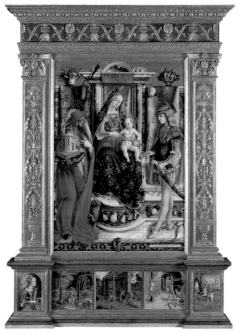

CARLO CRIVELLI (c. 1430/35–c. 1494).
La Madonna della Rondine
(The Madonna of the Swallow), c. 1490–92.
Tempera and oil on poplar, 59¼ x 42¼ in. (150.5 x 107.3 cm).

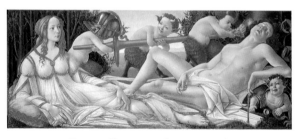

SANDRO BOTTICELLI (c. 1445–1510).
Venus and Mars, c. 1485.
Tempera and oil on poplar, 27¼ x 68¼ in. (69.2 x 173.4 cm).

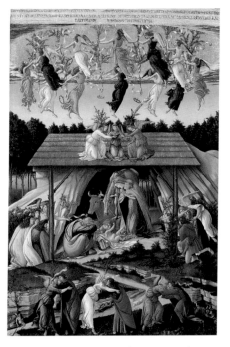

Sandro Botticelli (c. 1445–1510).
"Mystic Nativity," 1500.
Oil on canvas, 42¾ x 29⅛ in. (108.6 x 74.9 cm).

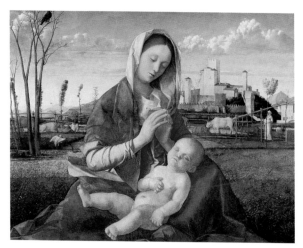

GIOVANNI BELLINI (active by c. 1459; died 1516).
The Madonna of the Meadow, c. 1500.
Oil and tempera on synthetic panel, transferred from wood,
26½ x 34 in. (67.3 x 86.4 cm).

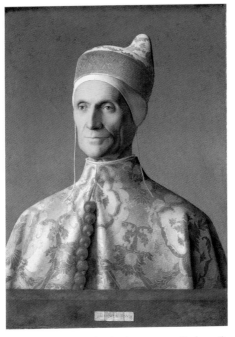

GIOVANNI BELLINI (active by c. 1459; died 1516).
The Doge Leonardo Loredan, 1501–4.
Oil on poplar, 24¼ x 17¾ in. (61.6 x 45.1 cm).

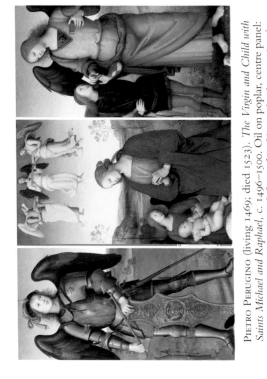

PIETRO PERUGINO (living 1469; died 1523). *The Virgin and Child with Saints Michael and Raphael*, c. 1496–1500. Oil on poplar, centre panel: 44⅜ x 22 in. (114 x 56 cm); left panel: 44⅜ x 25¼ in. (113 x 64 cm); right panel: 44½ x 22 in. (113 x 56 cm).

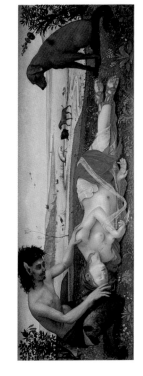

PIERO DI COSIMO (c. 1462–after 1515).
A Satyr Mourning over a Nymph, c. 1495.
Oil on poplar, 25¾ x 72½ in. (65.4 x 184.2 cm).

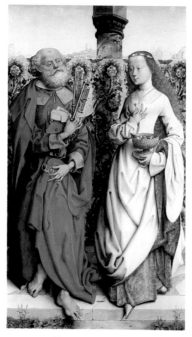

MASTER OF THE SAINT BARTHOLOMEW ALTARPIECE
(active c. 1470–c. 1510).
Saints Peter and Dorothy, probably 1505–10.
Oil on oak, 49½ x 28 in. (125.7 x 71.1 cm).

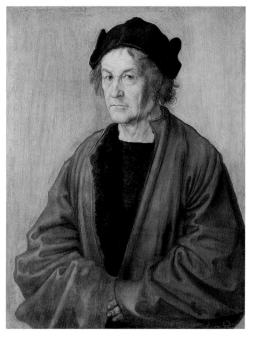

ATTRIBUTED TO ALBRECHT DÜRER (1471–1528).
The Painter's Father, 1497.
Oil on limewood, 20⅛ x 15⅞ in. (51 x 40.3 cm).

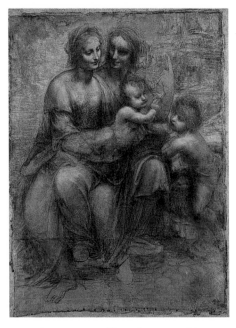

LEONARDO DA VINCI (1452–1519).
The Virgin and Child with Saint Anne and Saint John the Baptist
("The Leonardo Cartoon"), perhaps c. 1499–1500.
Charcoal and black and white chalk on tinted paper,
55¾ x 41¼ in. (141.5 x 104.6 cm).

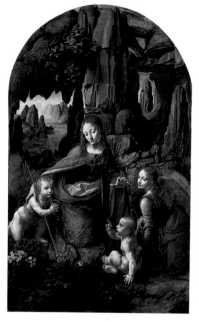

LEONARDO DA VINCI (1452–1519).
*The Virgin with the Infant Saint John Adoring the Infant Christ
Accompanied by an Angel ("The Virgin of the Rocks")*, c. 1508.
Oil on wood, 74⅝ x 47¼ in. (189.5 x 120 cm).

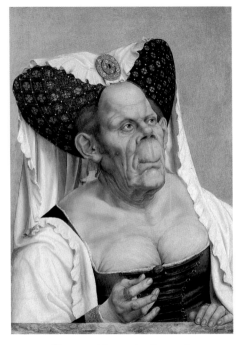

QUINTEN MASSYS (1465–1530).
A Grotesque Old Woman, c. 1525–30.
Oil on oak, 25¼ x 17⅞ in. (64.1 x 45.4 cm).

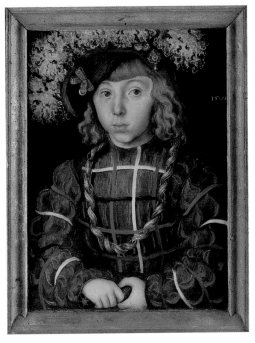

LUCAS CRANACH THE ELDER (1472–1553).
Portrait of Johann Friedrich the Magnanimous, 1509.
Oil on wood, 16½ x 12¼ in. (42 x 31.2 cm).

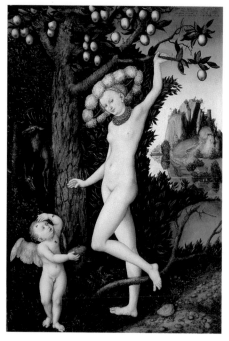

LUCAS CRANACH THE ELDER (1472–1553).
Cupid Complaining to Venus, probably early 1530s.
Oil on wood, 32 x 21½ in. (81.3 x 54.5 cm).

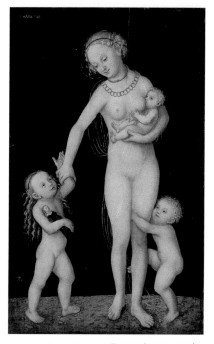

LUCAS CRANACH THE ELDER (1472–1553).
Charity, 1537–50.
Oil on beech, 22⅛ x 14¼ in. (56.3 x 36.2 cm).

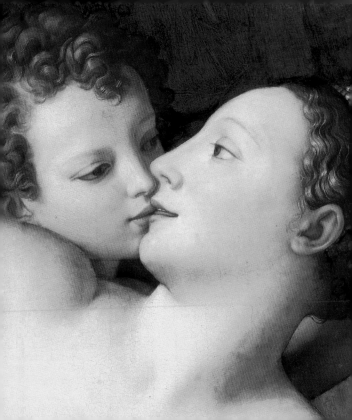

The West Wing:
Painting from 1510 to 1600

The revival of papal patronage in the sixteenth century made Rome once again a leading artistic centre. As ancient Roman artefacts were excavated and studied with renewed vigour, they—like the Florentine and Milanese works by Leonardo da Vinci—set new standards of monumentality, expressivity, and elegance in European art. Some of the greatest Italian artists of the next generation represented here—Raphael, Michelangelo, Correggio—demonstrated their debt to Leonardo and to the antique in the new breadth and scale of their figures, in the complexity of pose and composition, in the suavity of facial type and expression, and in a new delicacy of modelling, in which gradual transitions veil the steps from darkest shadow to highlight.

Even while working in oils, Leonardo had remained faithful to the Florentine traditions of fresco and tempera painting founded on line and tone, in which colour is an ornamental afterthought. This method of building up a painting can be followed clearly in Michelangelo's two unfinished panel pictures, *The Entombment* (page 89) and *"The Manchester Madonna"* (page 88). Painting in Venice, on the other hand, developed differently, perhaps under

the influence of the native tradition of mosaic. Following Giovanni Bellini and his pupil Giorgione—whose poetic *Il Tramonto (The Sunset)* is shown here (page 93)—Venetian artists took colour as the primary constituent of visual experience. They defined forms by transitions from one colour to another rather than through linear contour. Tonal differences were worked out not in shades of black and white but directly in colour. Compositions evolved throughout the process of painting, for they depended on the continuous adjustment of colour relationships; the use of oils made this possible. Venice, a great maritime power, had a highly developed shipping industry, and her artists increasingly turned from panel to canvas, the cloth used for sails.

As Titian, the greatest and most prolific Venetian master of the century, matured, his oil technique became bolder and more expressive. The weave of the canvas and the painter's gestures with brush and finger enliven the surface of his late pictures and enhance their emotional charge. We can follow his development in the West Wing from early works such as *The Holy Family and a Shepherd* of about 1510 (page 118) and the Giorgionesque *Noli Me Tangere* of around 1510–15 (page 119); through the vivid mythologies and portraits of his middle years; to the late, probably unfinished, *Death of Actaeon* of around 1565 (page 14), with its streaks and dabs and patches that, from

a distance, miraculously unite to form an image. Paolo Veronese, the adoptive Venetian who best interpreted Venice to herself, evolved a pictorial idiom in which even shaded areas of colour seem to reflect daylight. His "tableau vivant" of *The Family of Darius before Alexander* (page 142) is an especially splendid example. The influence of both artists was to extend across Europe and through the centuries.

The range of the Venetians' subject matter is an index of general developments in sixteenth-century art. Religious pictures continued to be commissioned; works from all over Europe attest to the vitality of this tradition. With the growing strength of the secular nation-state and the rise of centralised monarchies, portraiture became increasingly important as an instrument of statecraft and diplomatic exchange. The size of portraits tended to grow to the scale of life. Likenesses by the greatest painters of the age can be admired in the West Wing, including Hans Holbein's portrait of a prospective wife for Henry VIII of England (page 130) and works by the northern Italian portrait specialists Moretto da Brescia and Giovanni Battista Moroni. The emancipation of mythological subjects from small-scale furniture decoration to large pictorial spaces is an even more striking novelty of the period. Pagan gods and heroes came exuberantly alive as painters vied with the ancient poets; antique ideals of friendship

and magnanimity were exemplified; and antique nudity became an occasion for erotic display as well as a test of the artist's sophistication, as in Bronzino's tantalising *Allegory with Venus and Cupid* (page 134).

Collecting pictures for aesthetic and sensuous pleasure, and to demonstrate the patron's cultural aspirations, created a demand for still other types of imagery—notably, the autonomous landscape. The West Wing contains some of the earliest pure landscapes by Netherlandish and German painters. The beautiful small picture on copper (page 145) by Adam Elsheimer, a child of the sixteenth century but a pioneer of seventeenth-century art, introduces the theme of the northerner's nostalgia for the Mediterranean south and a mythical Golden Age—a major theme of works on view in the North Wing.

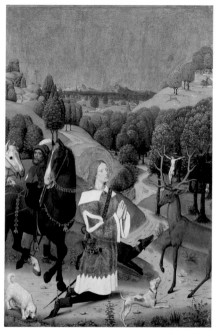

MASTER OF THE LIFE OF THE VIRGIN
(active second half of the 15th century).
The Conversion of Saint Hubert, probably c. 1480–85.
Oil on oak, 48½ x 32¾ in. (123 x 83.2 cm).

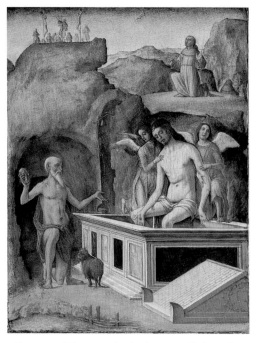

Ercole de' Roberti (active by 1479; died 1496).
The Dead Christ, c. 1490.
Tempera on wood, 7 x 5¼ in. (17.8 x 13.5 cm).

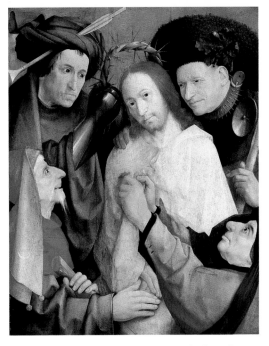

HIERONYMUS BOSCH (living 1474; died 1516).
Christ Mocked, c. 1490–1500.
Oil on oak, 29 x 23¼ in. (73.5 x 59.1 cm).

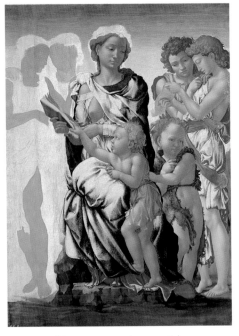

MICHELANGELO (1475–1564).
The Virgin and Child with Saint John and Angels
("The Manchester Madonna"), c. 1497.
Tempera and oil on wood, 41⅛ x 30¼ in. (104.5 x 77 cm).

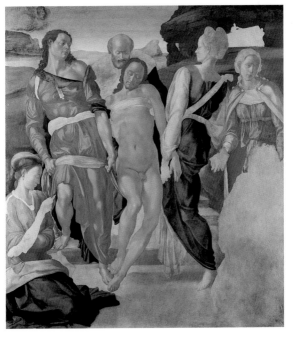

MICHELANGELO (1475–1564).
The Entombment, c. 1500–1501.
Oil on wood, 63⅝ x 59 in. (161.7 x 149.9 cm).

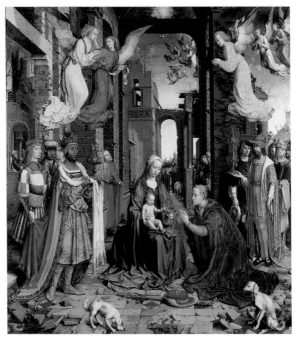

JAN GOSSAERT (active by 1503; died 1532).
The Adoration of the Kings, 1500–1515.
Oil on wood, 71 x 63½ in. (177.2 x 161.3 cm).

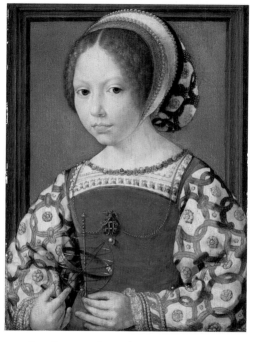

JAN GOSSAERT (active by 1503; died 1532).
A Little Girl, c. 1520.
Oil on oak, 15 x 11⅜ in. (38.1 x 28.9 cm).

GIORGIONE (active by 1506; died 1510).
The Adoration of the Kings, 1506–7.
Oil on wood, 11¾ x 32 in. (29.8 x 81.3 cm).

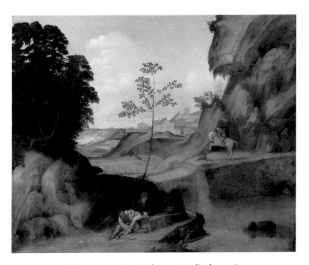

GIORGIONE (active by 1506; died 1510).
Il Tramonto (The Sunset), 1506–10.
Oil on canvas, 28⅞ x 36 in. (73.3 x 91.4 cm).

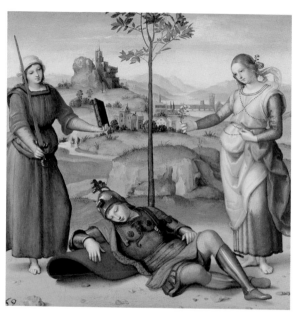

RAPHAEL (1483–1520).
An Allegory ("Vision of a Knight"), c. 1504.
Tempera on poplar, 6¾ x 6¾ in. (17.1 x 17.1 cm).

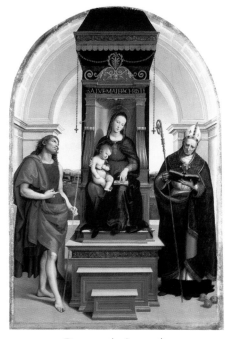

RAPHAEL (1483–1520).
The Madonna and Child with Saint John the Baptist and
Saint Nicholas of Bari (The Ansidei Madonna), 1505.
Oil on poplar, 82½ x 58½ in. (209.6 x 148.6 cm).

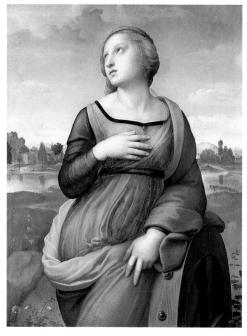

RAPHAEL (1483–1520).
Saint Catherine of Alexandria, c. 1507–8.
Oil on wood, 28⅛ x 22 in. (71.5 x 55.7 cm).

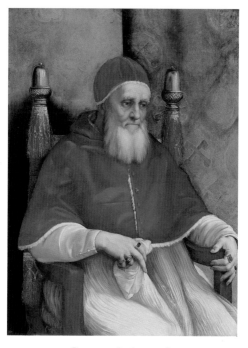

RAPHAEL (1483–1520).
Pope Julius II, 1511–12.
Oil on wood, 42½ x 31¾ in. (108 x 80.7 cm).

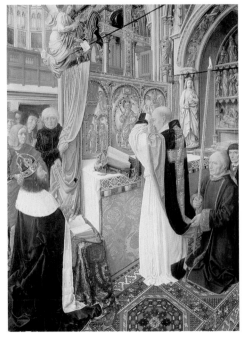

MASTER OF SAINT GILES (active c. 1500).
The Mass of Saint Giles, c. 1500.
Oil and tempera on oak, 24¼ x 18 in. (61.6 x 45.7 cm).

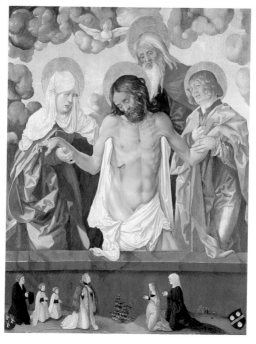

HANS BALDUNG GRIEN (1484/85–1545).
The Trinity and Mystic Pietà, 1512.
Oil on oak, 44¼ x 35⅛ in. (112.3 x 89.1 cm).

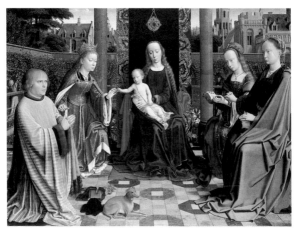

GERARD DAVID (active by 1484; died 1523).
The Virgin and Child with Saints and Donor, probably 1510.
Oil on oak, 41¾ x 56¾ in. (106 x 144.1 cm).

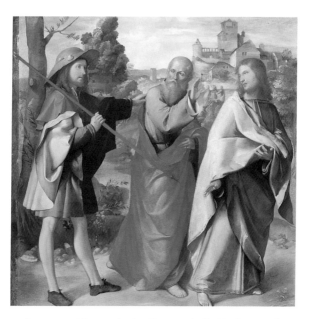

ALTOBELLO MELONE (active from 1516; died before 1543).
The Walk to Emmaus, c. 1516–20.
Oil on wood, 57¼ x 56¾ in. (145.4 x 144.1 cm).

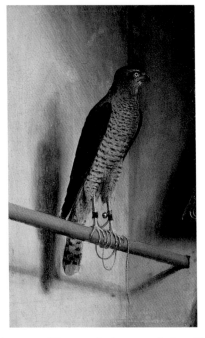

JACOPO DE' BARBARI (active 1500; died 1516?).
A Sparrowhawk, 1510s.
Oil on oak, 7 x 4¼ in. (17.8 x 10.8 cm).

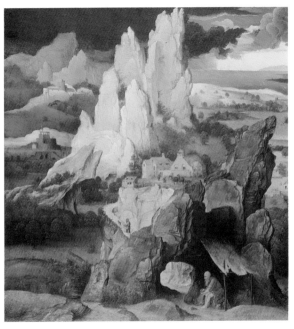

ATTRIBUTED TO JOACHIM PATENIER
(active by 1515; died by 1524).
Saint Jerome in a Rocky Landscape, probably 1515–24.
Oil on oak, 14¼ x 13½ in. (36.2 x 34.3 cm).

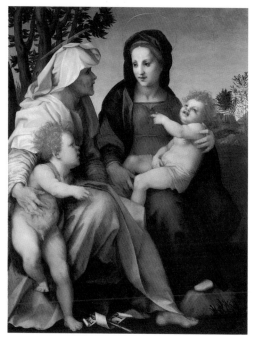

ANDREA DEL SARTO (1486–1530).
The Madonna and Child with Saint Elizabeth and Saint John the Baptist, c. 1513. Oil on wood, 41¾ x 32 in. (106 x 81.3 cm).

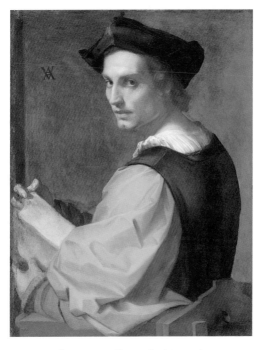

Andrea del Sarto (1486–1530).
Portrait of a Young Man, c. 1517–18.
Oil on linen, 28½ x 22½ in. (72.4 x 57.2 cm).

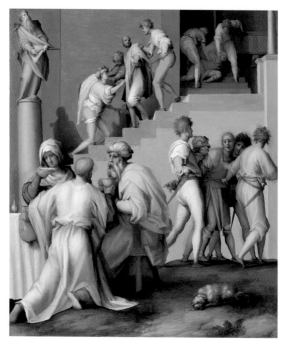

PONTORMO (1494-1557).
Pharaoh with His Butler and Baker, probably 1515.
Oil on wood, 24 x 20⅜ in. (61 x 51.7 cm).

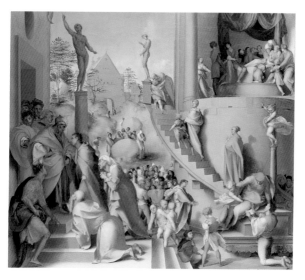

PONTORMO (1494–1557).
Joseph with Jacob in Egypt, probably 1518.
Oil on wood, 38 x 43⅛ in. (96.5 x 109.5 cm)

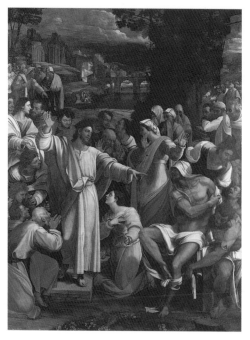

SEBASTIANO DEL PIOMBO (c. 1485–1547).
The Raising of Lazarus, c. 1517–19.
Oil on canvas, 150 x 114 in. (381 x 289.6 cm).

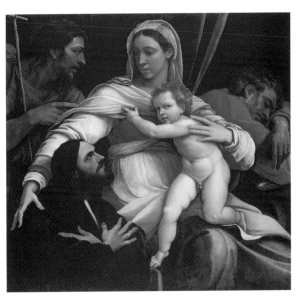

SEBASTIANO DEL PIOMBO (c. 1485–1547).
*The Madonna and Child with Saints Joseph and
John the Baptist and a Donor*, c. 1519–20.
Oil on wood, 38½ x 42 in. (97.8 x 106.7 cm).

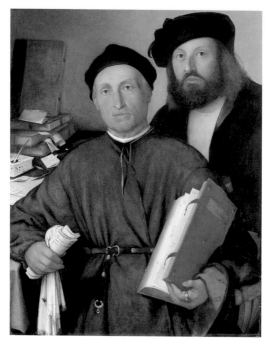

LORENZO LOTTO (c. 1480–after 1556).
The Physician Giovanni Agostino della Torre and His Son, Niccolò,
1515. Oil on canvas, 33¼ x 26¾ in. (84.5 x 67.9 cm).

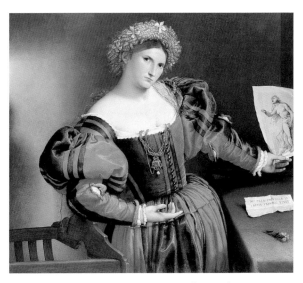

LORENZO LOTTO (c. 1480–after 1556).
A Lady with a Drawing of Lucretia, c. 1530–33. Oil on canvas,
37¾ x 43½ in. (95.9 x 110.5 cm).

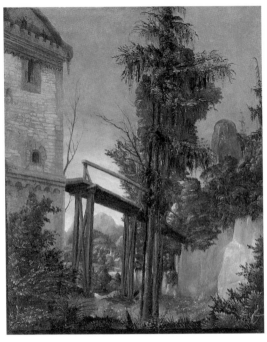

ALBRECHT ALTDORFER (shortly before 1480–1538).
Landscape with a Footbridge, c. 1518–20.
Oil on vellum on wood, 16¼ x 14 in. (41.2 x 35.5 cm).

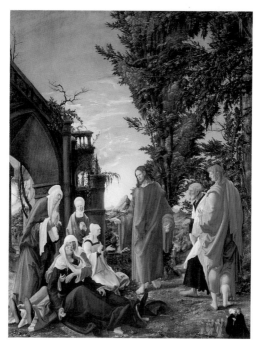

ALBRECHT ALTDORFER (shortly before 1480–1538).
Christ Taking Leave of His Mother, probably 1520.
Oil on limewood, 55½ x 43¾ in. (141 x 111 cm).

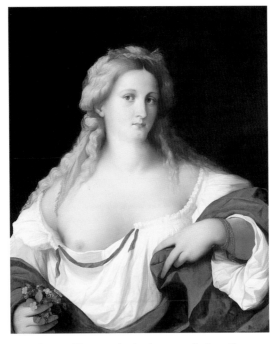

PALMA VECCHIO (active by 1510; died 1528).
A Blonde Woman, c. 1520.
Oil on wood, 30½ x 25¼ in. (77.5 x 64.1 cm).

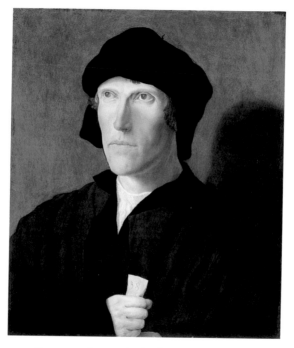

LUCAS VAN LEYDEN (active by 1508; died 1533).
A Man Aged Thirty-eight, c. 1521.
Oil on oak, 18¾ x 16 in. (47.6 x 40.6 cm).

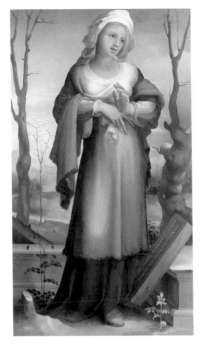

DOMENICO BECCAFUMI (1486?–1551).
Marcia, probably c. 1520–25.
Oil on wood, 36¼ x 21 in. (92.1 x 53.3 cm).

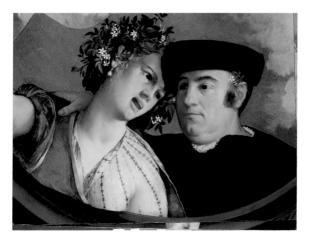

Dosso Dossi (active by 1512; died 1542).
A Man Embracing a Woman, probably c. 1524.
Oil on poplar, 21⅝ x 29¾ in. (55 x 75.5 cm).

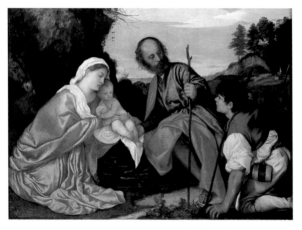

TITIAN (active by c. 1506; died 1576).
The Holy Family and a Shepherd, c. 1510.
Oil on canvas, 39 x 54¾ in. (99.1 x 139.1 cm).

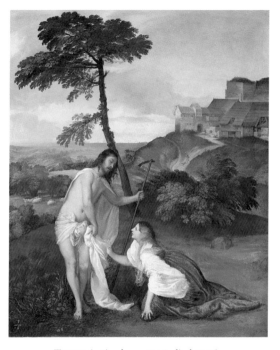

TITIAN (active by c. 1506; died 1576).
Noli Me Tangere, probably 1510–15.
Oil on canvas, 42¾ x 35¾ in. (108.6 x 90.8 cm).

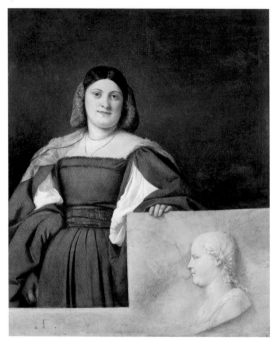

TITIAN (active by c. 1506; died 1576).
Portrait of a Lady, c. 1511.
Oil on canvas, 47 x 38 in. (119.4 x 96.5 cm).

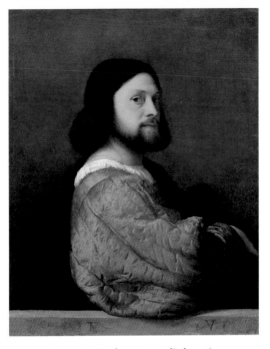

TITIAN (active by c. 1506; died 1576).
Portrait of a Man, c. 1512.
Oil on canvas, 32 x 26⅛ in. (81.2 x 66.3 cm).

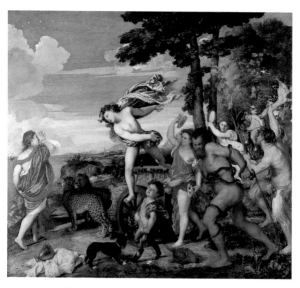

Titian (active by c. 1506; died 1576).
Bacchus and Ariadne, 1522–23.
Oil on canvas, 69 x 75 in. (175.2 x 190.5 cm).

Titian (active c. 1506; died 1576).
The Vendramin Family, 1543–47.
Oil on canvas, 79 x 118½ in. (205.7 x 301 cm).

CORREGGIO (c. 1494–died 1534).
The Madonna of the Basket, c. 1524.
Oil on wood, 13¼ x 9⅞ in. (33.7 x 25.1 cm).

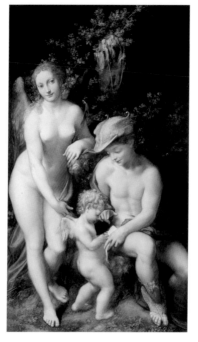

CORREGGIO (c. 1494–died 1534).
Venus with Mercury and Cupid ("The School of Love"), c. 1525.
Oil on canvas, 61¼ x 36 in. (155.6 x 91.4 cm).

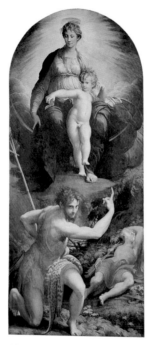

PARMIGIANINO (1503–1540).
The Madonna and Child with Saints John the Baptist and Jerome,
1526–27. Oil on poplar, 135 x 58½ in. (342.9 x 148.6 cm).

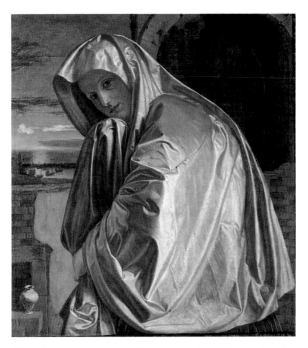

GIAN GIROLAMO SAVOLDO (born c. 1480/85; active 1508–48).
Saint Mary Magdalene Approaching the Sepulchre, probably
1530–48. Oil on canvas, 34 x 31¼ in. (86.4 x 79.4 cm).

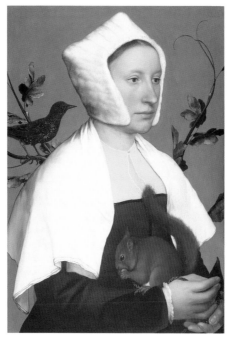

HANS HOLBEIN THE YOUNGER (1497/98–1543).
Lady with a Squirrel and a Starling, c. 1526–28.
Oil on oak, 22 x 15¼ in. (56 x 38.8 cm).

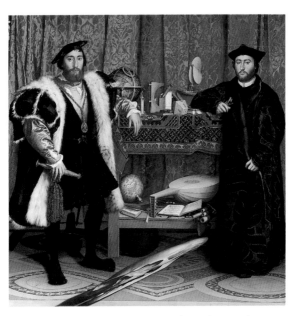

HANS HOLBEIN THE YOUNGER (1497/98–1543).
Jean de Dinteville and Georges de Selve ("The Ambassadors"),
1533. Oil on oak, 81½ x 82½ in. (207 x 209.5 cm).

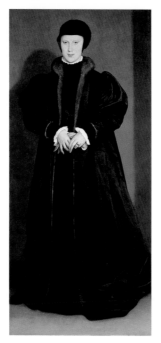

HANS HOLBEIN THE YOUNGER (1497/98–1543).
Christina of Denmark, Duchess of Milan, probably 1538.
Oil on oak, 70½ x 32½ in. (179.1 x 82.6 cm).

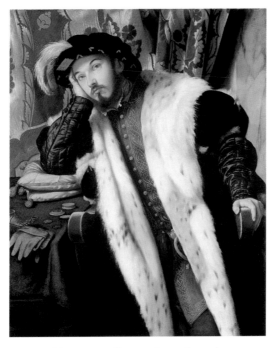

MORETTO DA BRESCIA (c. 1498–1554).
Portrait of a Young Man, c. 1542.
Oil on canvas, 44¾ x 37 in. (113.7 x 94 cm).

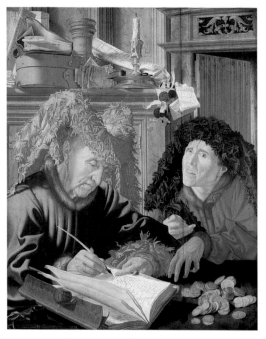

MARINUS VAN REYMERSWAELE
(active by 1509?; died after 1567?).
Two Tax Gatherers, probably c. 1540.
Oil on oak, 36¼ x 29¼ in. (92.1 x 74.3 cm).

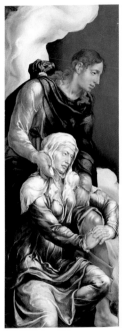

MARTIN VAN HEEMSKERCK (1498–1574).
The Virgin and Saint John the Evangelist, c. 1540.
Oil on oak, 48½ x 18⅛ in. (123 x 46 cm).

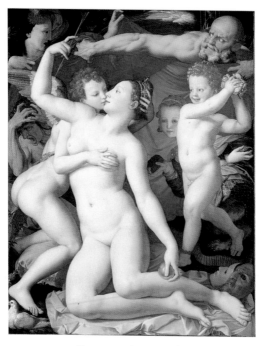

BRONZINO (1503–1572).
An Allegory with Venus and Cupid, probably 1540–50.
Oil on wood, 57½ x 45¾ in. (146.1 x 116.2 cm).

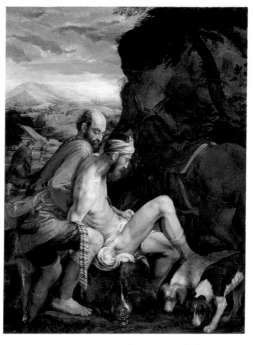

JACOPO BASSANO (active by c. 1535; died 1592).
The Good Samaritan, probably 1550–70.
Oil on canvas, 40 x 31¼ in. (101.5 x 79.4 cm).

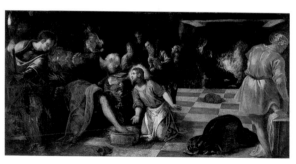

TINTORETTO (1518–1594).
Christ Washing His Disciples' Feet, c. 1556.
Oil on canvas, 79 x 160¾ in. (200.6 x 408.3 cm).

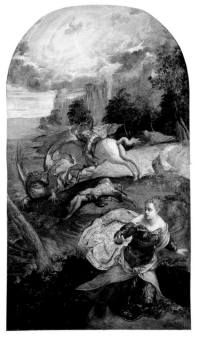

TINTORETTO (1518–1594).
Saint George and the Dragon, probably 1560–80.
Oil on canvas, 62 x 39½ in. (157.5 x 100.3 cm).

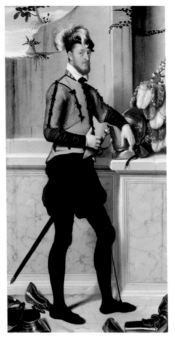

GIOVANNI BATTISTA MORONI (c. 1520/24–1578).
Portrait of a Gentleman (Il Cavaliere dal Piede Ferito), probably
c. 1555–60. Oil on canvas, 79⅝ x 41¾ in. (202.2 x 106 cm).

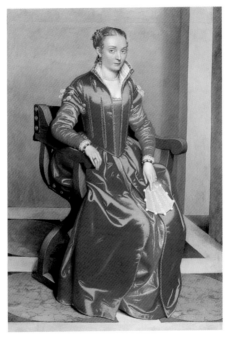

GIOVANNI BATTISTA MORONI (c. 1520/24–1578).
Portrait of a Lady (La Dama in Rosso), probably c. 1555–60.
Oil on canvas, 60⅞ x 42 in. (154.6 x 106.7 cm).

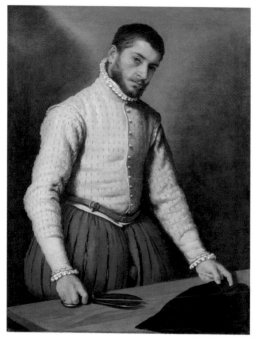

GIOVANNI BATTISTA MORONI (c. 1520/24–1578).
Portrait of a Man ("The Tailor"), c. 1570.
Oil on canvas, 38½ x 29½ in. (97.8 x 74.9 cm).

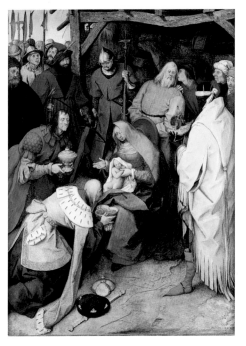

PIETER BRUEGEL THE ELDER (c. 1525–1569).
The Adoration of the Kings, 1564.
Oil on oak, 43¾ x 32¾ in. (111.1 x 83.2 cm).

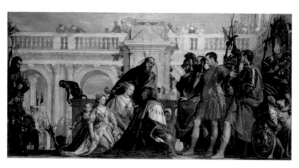

PAOLO VERONESE (probably 1528–1588).
The Family of Darius before Alexander, 1565–70.
Oil on canvas, 93 x 187 in. (236.2 x 474.9 cm).

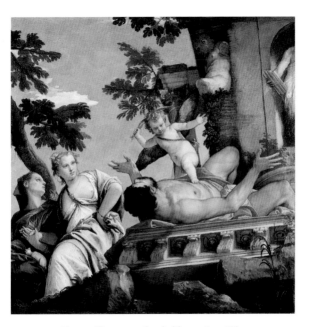

PAOLO VERONESE (probably 1528–1588).
Allegory of Love, II ("Scorn"), probably 1570s.
Oil on canvas, 73½ x 74¼ in. (186.6 x 188.5 cm).

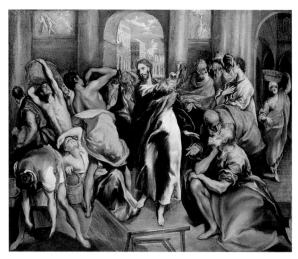

EL GRECO (1541–1614).
Christ Driving the Traders from the Temple, c. 1600.
Oil on canvas, 41⅞ x 51 in. (106.3 x 129.7 cm).

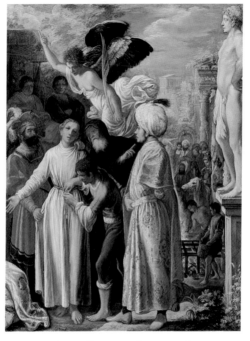

ADAM ELSHEIMER (1578–1610).
Saint Lawrence Prepared for Martyrdom, c. 1600–1601.
Oil on copper, 10½ x 8⅛ in. (26.7 x 20.6 cm).

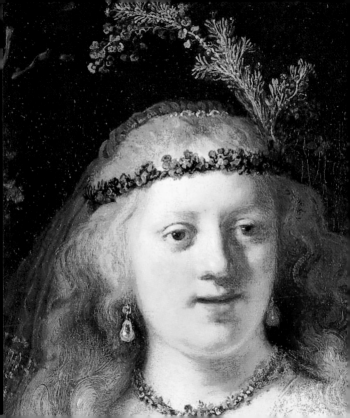

THE NORTH WING:
PAINTING FROM 1600 TO 1700

After 1600, when the achievements of the Italian Renaissance had become the common currency of all European art, the dominance of Italian painting was challenged by Flemish, Dutch, Spanish, and French artists—reflecting religious, political, and economic developments in Europe that affected conditions of patronage and production. The North Wing contains a large number of works by Peter Paul Rubens, the great Flemish painter. Having spent eight years in Italy, Rubens forged his own vivid manner out of Venetian colourism, Michelangelesque and classical figures, and Italianate and Netherlandish themes—as in the magnificent *Samson and Delilah* (page 161), painted shortly after his return to Antwerp in 1608. A cultivated man, he was employed as a diplomatic envoy as well as a painter; his international career touched on the complex affairs of the Spanish Netherlands and the kingdoms of Spain, England, and France. *Minerva Protects Pax from Mars* ("Peace and War") (page 164), given by the artist to Charles I, is an eloquent testimony to Rubens's humane ideals and his mastery of the classical language of allegory. Anthony van Dyck, the youthful prodigy who had once been Rubens's chief assistant, is also well represented with works executed in

Antwerp, Genoa, and London. The life-size *Equestrian Portrait of Charles I* (page 182) encapsulates all the themes of Stuart absolutist propaganda.

The northern provinces of the Netherlands, under the leadership of the most powerful, Holland, broke away from Spanish rule early in the century. With the adoption of Calvinism as the state religion, Dutch painters lost the traditional patronage of the Church. In place of devotional art, new patriotic forms of secular painting were evolved for the growing domestic market. The North Wing houses a vast collection of sea, river, and canal views celebrating Dutch naval and shipping might, of landscapes depicting windmills and flat lands reclaimed from the sea, of Dutch townscapes, of still lifes glorying in native and exotic produce or warning against the futility of earthly attachments, and of portraits honoring Dutch men and women as well as pictures of them at work and at play, at home and abroad, or tending the dairy herds that were Holland's emblem. The greatest Dutch painter of the century, Rembrandt, is represented by some twenty pictures, including heroic biblical narratives and self-portraits.

Paradoxically, it was an Italian, Michelangelo Merisi da Caravaggio (born and trained in Lombardy), who broke the spell cast over European figure painters by the idealising art of the Italian Renaissance. When he first

came to Rome at the turn of the century Caravaggio was as mindful of Leonardo, who had worked in Milan, and of the Venetian Giorgione as of the uncompromising realism of German art, long influential on his native region. But in Rome, working directly from models found in the streets and taverns, dramatically exaggerating the contrast between light and shade, he seemed the very incarnation of an artist rebelling against the past. His *Supper at Emmaus* (page 151) still fascinates visitors with its immediacy and earthiness. Although he attracted Italian followers, Caravaggio's greatest influence was among the foreign artists who flocked to Rome. When, after killing a man, he fled to Spanish-ruled Naples, his influence spread to the Iberian peninsula.

Although we do not know precisely how it was transmitted at such an early date, Caravaggio's manner is evident in the "low-life" paintings of Diego Velázquez's youthful years in Seville, such as *Kitchen Scene with Christ in the House of Martha and Mary* (page 166). Velázquez's own style eventually changed—as in the famous *"Rokeby Venus"* (page 169) and the impressionistic *Philip IV of Spain in Brown and Silver* (page 168)—under the impact of the Venetian sixteenth-century pictures in the royal collections, which he came to know as court painter in Madrid. But Caravaggio's dramatic tenebrism persisted in the work of Velázquez's Sevillian contemporary Francisco de Zurbarán.

Adam Elsheimer's poetic landscapes, on view in the West Wing, spawned the new genre of the "ideal" or "poetic" landscape, made internationally famous by two French-speaking northerners working in Rome: Claude from the Duchy of Lorraine and Nicolas Poussin from Normandy. In their works painted for aristocrats, princes of the Church, or cultivated professional men, the Roman Campagna is portrayed as an idyllic land, where ancient fables and rites are enacted and where gods and men live in harmony with nature. Both artists were to influence later painters throughout Europe; Claude's pictures were to be copied by the landscape designers of eighteenth-century English country estates.

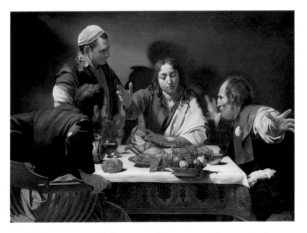

Michelangelo Merisi da Caravaggio (1571–1610).
The Supper at Emmaus, 1601.
Oil and tempera on canvas, 55½ x 77¼ in. (141 x 196.2 cm).

ANNIBALE CARRACCI (1560–1609).
Christ Appearing to Saint Peter on the Appian Way
(Domine, Quo Vadis?), 1601–2.
Oil on wood, 30½ x 22⅛ in. (77.4 x 56.3 cm).

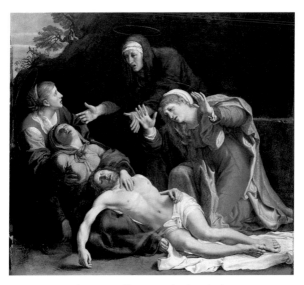

ANNIBALE CARRACCI (1560–1609).
The Dead Christ Mourned ("The Three Maries"), c. 1604.
Oil on canvas, 37 x 41¼ in. (92.8 x 103.2 cm).

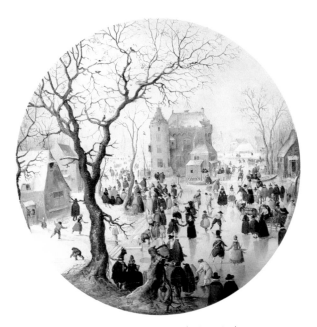

HENDRICK AVERCAMP (1585–1634).
A Winter Scene with Skaters near a Castle, c. 1608/9.
Oil on oak, diameter: 16 in. (40.7 cm).

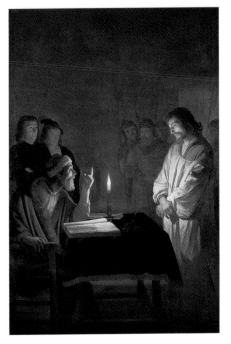

GERRIT VAN HONTHORST (1592–1656).
Christ before the High Priest, c. 1617.
Oil on canvas, 107⅛ x 72 in. (272 x 183 cm).

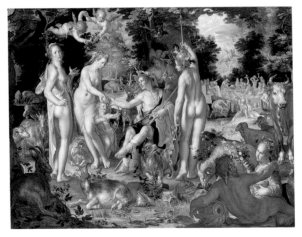

JOACHIM WTEWAEL (1566–1638).
The Judgement of Paris, 1615.
Oil on oak, 23½ x 31¼ in. (59.8 x 79.2 cm).

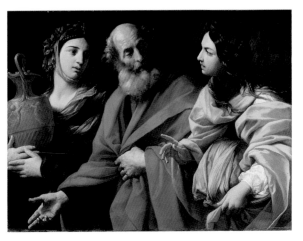

GUIDO RENI (1575–1642).
Lot and His Daughters Leaving Sodom, c. 1615–16.
Oil on canvas, 43¾ x 58¾ in. (111.2 x 149.2 cm).

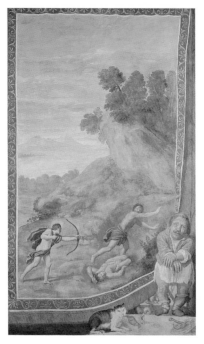

DOMENICHINO (1581–1641).
Apollo Killing the Cyclops, 1616–18. Fresco, transferred to canvas and mounted on board, 124½ x 75 in. (316.3 x 190.4 cm).

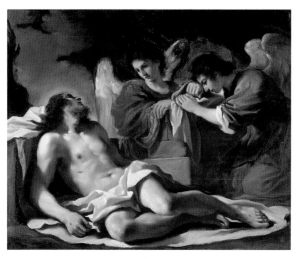

GUERCINO (1591–1666).
The Dead Christ Mourned by Two Angels, c. 1617–18.
Oil on copper, 14½ x 17½ in. (36.8 x 44.4 cm).

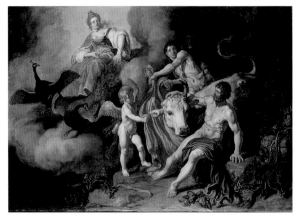

PIETER LASTMAN (1583–1633).
Juno Discovering Jupiter with Io, 1618.
Oil on oak, 21⅜ x 30⅝ in. (54.3 x 77.8 cm).

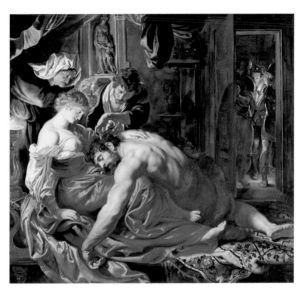

PETER PAUL RUBENS (1577–1640).
Samson and Delilah, c. 1609.
Oil on wood, 72⅞ x 80¾ in. (185 x 205 cm).

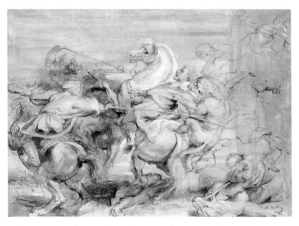

PETER PAUL RUBENS (1577–1640).
A Lion Hunt, c. 1616–17.
Oil on oak, 29 x 41½ in. (73.6 x 105.4 cm).

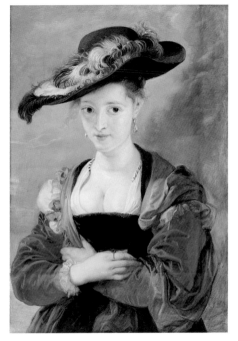

PETER PAUL RUBENS (1577–1640).
Portrait of Susanna Lunden(?) ("Le Chapeau de Paille"), probably
1622–25. Oil on oak, 31⅛ x 21½ in. (79 x 54.5 cm).

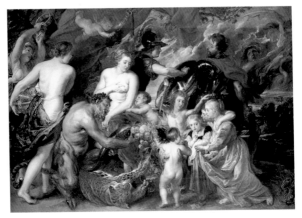

PETER PAUL RUBENS (1577–1640).
Minerva Protects Pax from Mars ("Peace and War"), 1629–30.
Oil on canvas, 80⅛ x 117⅜ in. (203.5 x 298 cm).

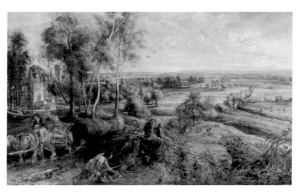

PETER PAUL RUBENS (1577–1640).
*An Autumn Landscape with a View of Het Steen
in the Early Morning,* probably 1636.
Oil on oak, 51⅝ x 90¼ in. (131.2 x 229.2 cm).

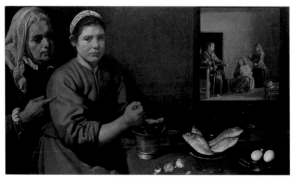

DIEGO VELÁZQUEZ (1599–1660).
Kitchen Scene with Christ in the House of Martha and Mary,
probably 1618. Oil on canvas, 23⅝ x 40¾ in. (60 x 103.5 cm).

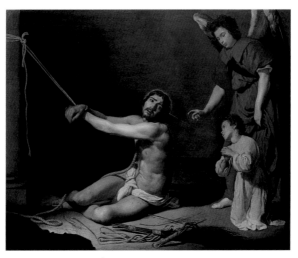

Diego Velázquez (1599–1660).
*Christ after the Flagellation Contemplated
by the Christian Soul*, probably 1628–29.
Oil on canvas, 65 x 81¼ in. (165.1 x 206.4 cm).

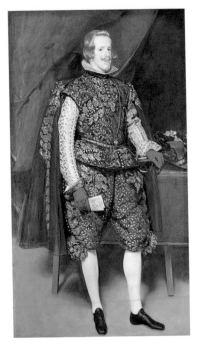

DIEGO VELÁZQUEZ (1599–1660).
Philip IV of Spain in Brown and Silver, c. 1631–32.
Oil on canvas, 76¾ x 43¼ in. (195 x 110 cm).

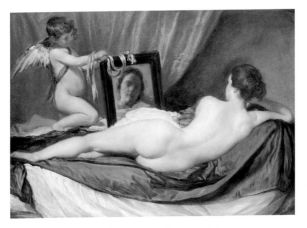

DIEGO VELÁZQUEZ (1599–1660).
The Toilet of Venus ("The Rokeby Venus"), 1647–51.
Oil on canvas, 48¼ x 69¾ in. (122.5 x 177 cm).

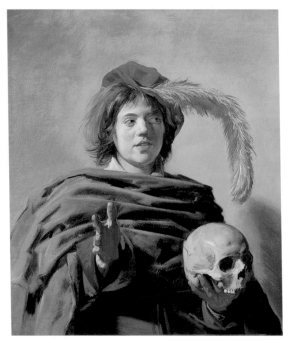

FRANS HALS (c. 1580?–1666).
Young Man Holding a Skull, 1626–28.
Oil on canvas, 36¼ x 34⅝ in. (92.2 x 88 cm).

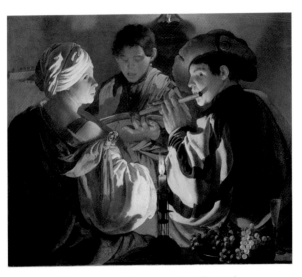

HENDRICK TER BRUGGHEN (1588?–1629).
The Concert, c. 1626.
Oil on canvas, 39 x 48 in. (99.1 x 116.8 cm).

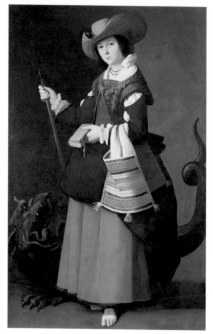

FRANCISCO DE ZURBARÁN (1598–1664).
Saint Margaret of Antioch, 1630–34.
Oil on canvas, 66¼ x 41⅜ in. (163 x 105 cm).

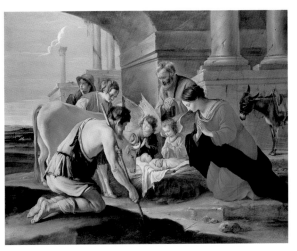

LE NAIN BROTHERS (ANTOINE [c. 1600–1648],
LOUIS [c. 1603–1648], and MATHIEU [c. 1607–1677]).
The Adoration of the Shepherds, probably late 1630s.
Oil on canvas, 43⅛ x 54⅛ in. (109.5 x 137.4 cm).

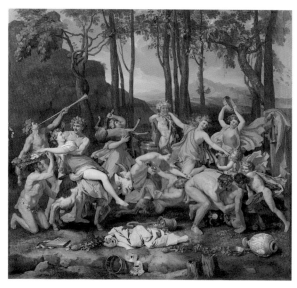

NICOLAS POUSSIN (1594–1665).
The Triumph of Pan, 1636.
Oil on canvas, 52¾ x 57⅛ in. (134 x 145 cm).

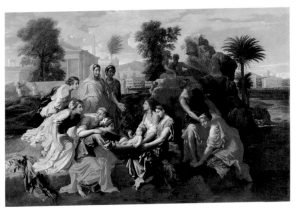

NICOLAS POUSSIN (1594–1665).
The Finding of Moses, 1651.
Oil on canvas, 45¾ x 69⅞ in. (116 x 177.5 cm).

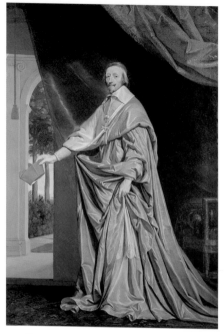

PHILIPPE DE CHAMPAIGNE (1602–1674).
Cardinal Richelieu, c. 1637.
Oil on canvas, 102¼ x 70 in. (259.7 x 177.8 cm).

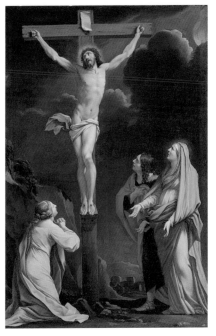

EUSTACHE LE SUEUR (1616–1655).
Christ on the Cross with the Magdalen, the Virgin Mary,
and Saint John the Evangelist, c. 1642.
Oil on canvas, 43⅛ x 29 in. (109.5 x 73.8 cm).

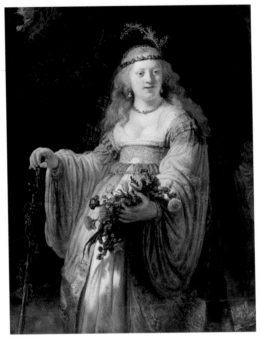

REMBRANDT (1606–1669).
Saskia van Uylenburgh in Arcadian Costume, 1635.
Oil on canvas, 48⅝ x 38⅜ in. (123.5 x 97.5 cm).

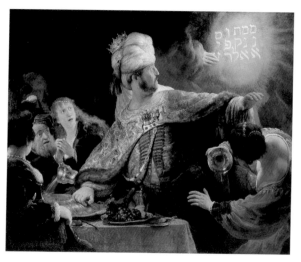

REMBRANDT (1606–1669).
Belshazzar's Feast, c. 1636–38.
Oil on canvas, 66 x 82⅜ in. (167.6 x 209.2 cm).

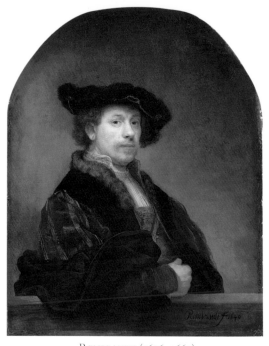

REMBRANDT (1606–1669).
Self-Portrait at the Age of Thirty-four, 1640.
Oil on canvas, 40⅛ x 31½ in. (102 x 80 cm).

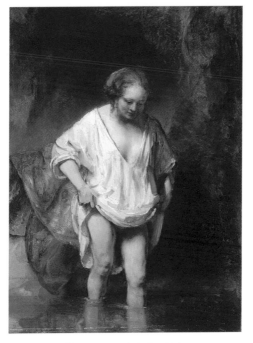

Rembrandt (1606–1669).
A Woman Bathing in a Stream (Hendrickje Stoffels?), 1654.
Oil on oak, 24⅜ x 18½ in. (61.8 x 47 cm).

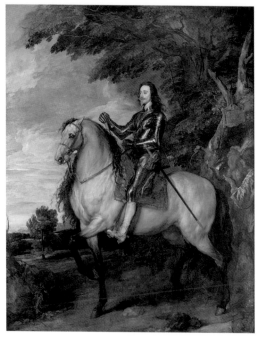

ANTHONY VAN DYCK (1599–1641).
Equestrian Portrait of Charles I, c. 1637–38.
Oil on canvas, 144½ x 115 in. (367 x 292.1 cm).

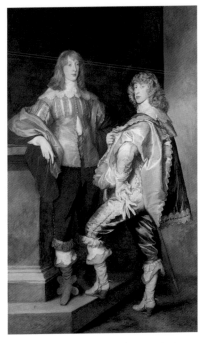

ANTHONY VAN DYCK (1599–1641).
Lord John Stuart and His Brother, Lord Bernard Stuart, c. 1638.
Oil on canvas, 93½ x 57½ in. (237.5 x 146.1 cm).

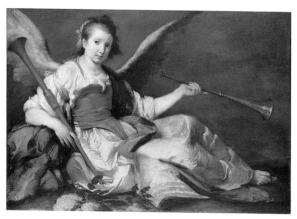

BERNARDO STROZZI (1581–1644).
A Personification of Fame, probably 1635–36.
Oil on canvas, 42 x 59¾ in. (106.7 x 151.7 cm).

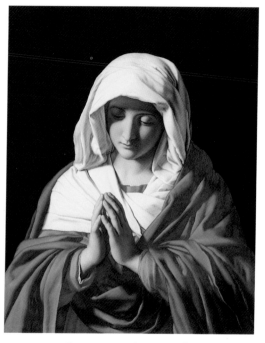

SASSOFERRATO (1609–1685).
The Virgin in Prayer, 1640–50.
Oil on canvas, 28¾ x 22¾ in. (73 x 57.7 cm).

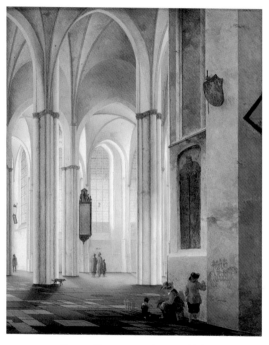

PIETER SAENREDAM (1597–1665).
The Interior of the Buurkerk at Utrecht, 1644.
Oil on oak, 23⅝ x 19¾ in. (60.1 x 50.1 cm).

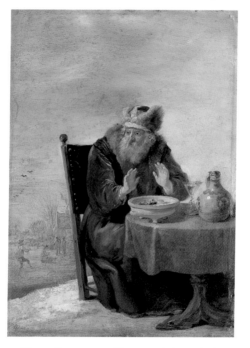

DAVID TENIERS THE YOUNGER (1610–1690).
The Four Seasons: Winter, c. 1644.
Oil on copper, 8⅝ x 6⅜ in. (22 x 16.3 cm).

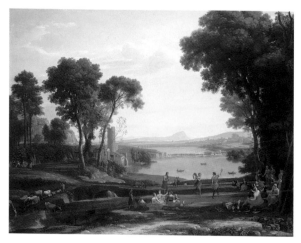

CLAUDE (1604/5?–1682).
Landscape with the Marriage of Isaac and Rebekah ("The Mill"),
1648. Oil on canvas, 58¾ x 77½ in. (149.2 x 196.9 cm).

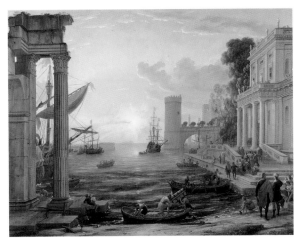

CLAUDE (1604/5?–1682).
Seaport with the Embarkation of the Queen of Sheba, 1648.
Oil on canvas, 59½ x 77½ in. (148.6 x 193.7 cm).

JAN JANSZ. TRECK (1605/6–1652).
Vanitas Still Life, 1648.
Oil on oak, 35⅝ x 30⅞ in. (90.5 x 78.4 cm).

CARLO DOLCI (1616–1686).
The Adoration of the Kings, 1649.
Oil on canvas, 46 x 36¼ in. (117 x 92 cm).

JAN VAN DE CAPPELLE (1626–1679).
*A Dutch Yacht Firing a Salute as a Barge Pulls Away,
and Many Small Vessels at Anchor*, 1650.
Oil on oak, 33⅝ x 45⅛ in. (85.5 x 114.5 cm).

AELBERT CUYP (1620–1691).
River Landscape with Horseman and Peasants, probably 1650–60.
Oil on canvas, 48½ x 94⅞ in. (123 x 241 cm).

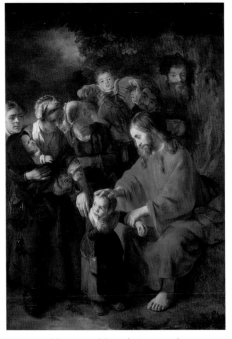

NICOLAES MAES (1634–1693).
Christ Blessing the Children, 1652–53.
Oil on canvas, 81⅛ x 60⅝ in. (206 x 154 cm).

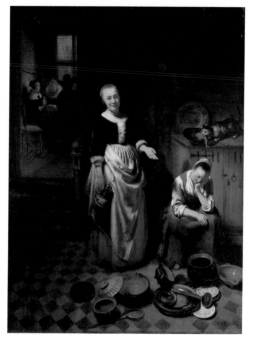

NICOLAES MAES (1634–1693).
Interior with a Sleeping Maid and Her Mistress ("The Idle Servant"), 1655. Oil on oak, 27½ x 21 in. (70 x 53.3 cm).

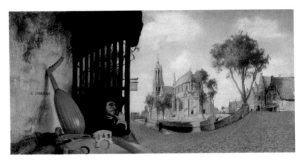

CAREL FABRITIUS (1622–1654).
A View of Delft, with a Musical Instrument Seller's Stall, 1652. Oil
on canvas mounted on walnut, 6⅛ x 12½ in. (15.5 x 31.7 cm).

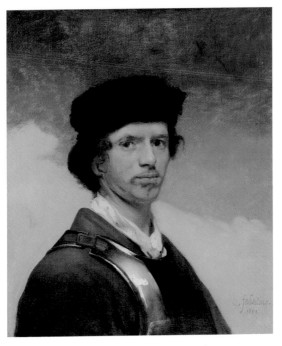

CAREL FABRITIUS (1622–1654).
A Young Man in a Fur Cap and Cuirass (Self-Portrait?), 1654.
Oil on canvas, 27¾ x 24¼ in. (70.5 x 61.5 cm).

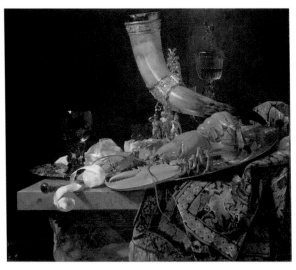

WILLEM KALF (1619–1693).
Still Life with the Drinking Horn of the Saint Sebastian
Archers' Guild, Lobster, and Glasses, c. 1653.
Oil on canvas, 34 x 40¼ in. (86.4 x 102.2 cm).

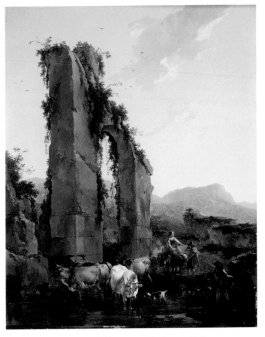

NICOLAES BERCHEM (1620–1683).
*Peasants with Four Oxen and a Goat at a Ford
by a Ruined Aqueduct*, probably 1655–60.
Oil on oak, 18½ x 15¼ in. (47.1 x 38.7 cm).

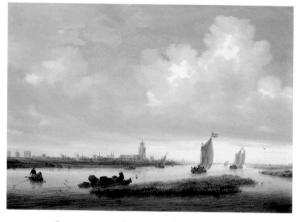

SALOMON VAN RUYSDAEL (1600/3?–1670).
A View of Deventer Seen from the North-West, 1657.
Oil on wood, 20⅜ x 30⅛ in. (51.8 x 76.5 cm).

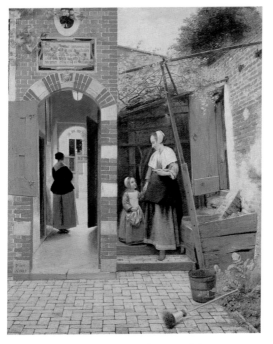

PIETER DE HOOCH (1629–1684).
The Courtyard of a House in Delft, 1658.
Oil on canvas, 29 x 23⅝ in. (73.5 x 60 cm).

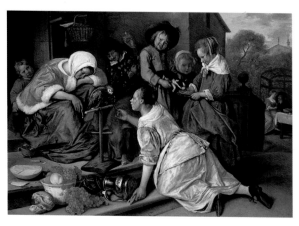

JAN STEEN (1625/26–1679).
The Effects of Intemperance, c. 1663–65.
Oil on wood, 29⅞ x 42 in. (76 x 106.5 cm).

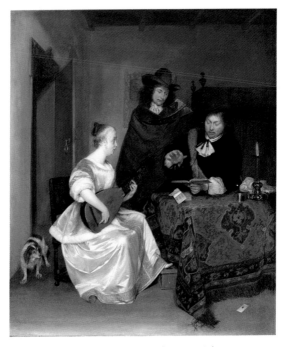

GERARD TER BORCH (1617–1681).
A Woman Playing a Theorbo to Two Men, c. 1667–68.
Oil on canvas, 26⅝ x 22¾ in. (67.6 x 57.8 cm).

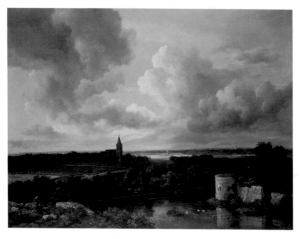

JACOB VAN RUISDAEL (1628/29?–1682).
A Landscape with a Ruined Castle and a Church, c. 1665–70.
Oil on canvas, 42⅞ x 57½ in. (109 x 146 cm).

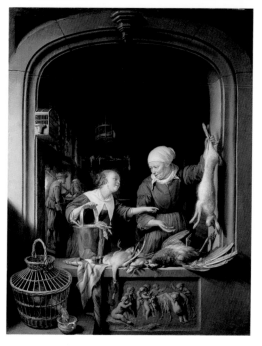

GERRIT DOU (1613–1675).
A Poulterer's Shop, c. 1670.
Oil on oak, 22⅞ x 18⅛ in. (58 x 46 cm).

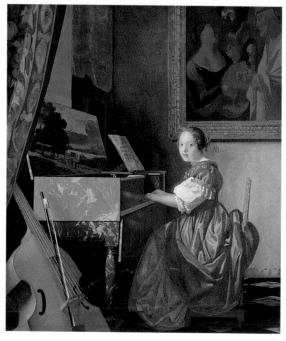

JAN VERMEER (1632–1675).
A Young Woman Seated at a Virginal, c. 1670.
Oil on canvas, 20¼ x 17⅞ in. (51.5 x 45.5 cm).

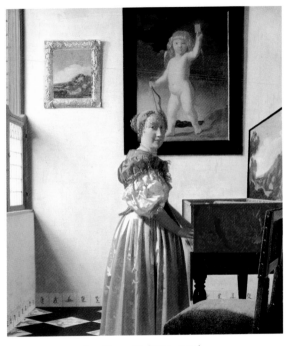

JAN VERMEER (1632–1675).
A Young Woman Standing at a Virginal, c. 1670.
Oil on canvas, 20⅜ x 17¾ in. (51.7 x 45.2 cm).

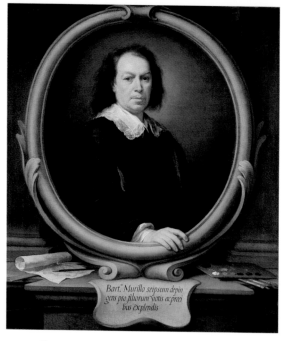

Bart.ᵐᵉ Murillo seipsum depin gens pro filiorum votis acpreci bus explendis

BARTOLOMÉ ESTEBAN MURILLO (1617–1682).
Self-Portrait, probably 1670–73.
Oil on canvas, 48 x 42⅛ in. (122 x 107 cm).

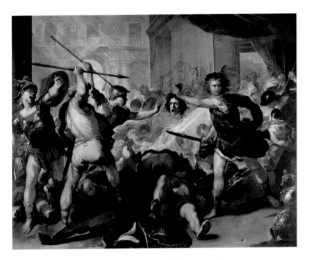

Lucª Giordano (1634–1705).
Perseus Turning Phineas and His Followers to Stone, early 1680s.
Oil on canvas, 112¼ x 144⅛ in. (285 x 366 cm).

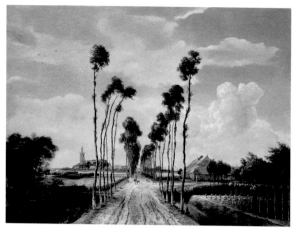

MEINDERT HOBBEMA (1638–1709).
The Avenue at Middelharnis, 1689.
Oil on canvas, 40¾ x 55½ in. (103.5 x 141 cm).

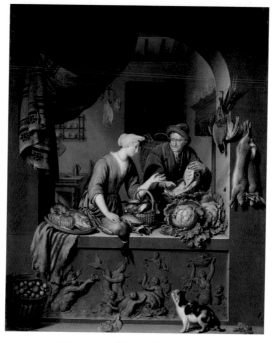

WILLEM VAN MIERIS (1662–1747).
A Woman and a Fish-Pedlar in a Kitchen, 1713.
Oil on oak, 19½ x 16⅛ in. (49.5 x 41 cm).

The East Wing:
Painting from 1700 to 1900

The eighteenth century saw the establishment of art academies across Europe and, simultaneously, the rise of professional colour sellers and canvas merchants—both spelling the virtual divorce of the "art" from the "craft" of painting. As painters came to know less about the physical properties of their pigments and media, their technique became, for good or ill, less tradition-bound. The fugitive red glazes used to create flesh tones in many of Joshua Reynolds's portraits faded so rapidly that contemporaries complained "his pictures die before the man." Some hundred years later, however, Pierre-Auguste Renoir's *Boating on the Seine* (page 266) of around 1879-80 juxtaposed brilliant new synthetic pigments squeezed straight from the tube, successfully demonstrating the recently proposed "law of simultaneous contrast." Claude Monet, by accidentally incorporating sand in his rapidly painted *Beach at Trouville* (page 269), enhanced its spontaneity.

Even though the techniques of the Old Masters were largely forgotten, the categories of painting they had developed—epic narrative or "history painting," both religious and secular; portraiture; the painting of everyday life, also called genre painting; landscape; and still life—were codified in a hierarchy of esteem. So well

were the conventions of each category understood by artists and viewers alike that these conventions became carriers of meaning. For example, Canaletto's large views of Venice are, through their commanding size alone, more solemn souvenirs of the eighteenth-century English noble's Grand Tour than Guardi's intimate *capricci*, meant for the eyes of a single viewer.

Even bigger pictures, on a real-life scale, were associated with "history painting" and the grand portrait of status. When Georges Seurat interpreted a traditionally modest genre subject, working men at leisure, on a monumental scale in his *Bathers at Asnières* of 1884 (page 276), the effect was electrifying, for he was conferring on them the dignity of heroes or monarchs. The same device used by Joseph Wright of Derby in his 1768 picture *An Experiment on a Bird in the Air Pump* (page 234) alerts us to the metaphysical dimension of this scene of family and friends witnessing a scientific demonstration; the cosy gathering is revealed to be a meditation on nothing less than life and death. Alternatively, the tragic story of Hogarth's *Marriage à la Mode,* painted before 1743 (page 223), becomes comic satire by being narrated in a series of detailed small pictures of the kind associated with seventeenth-century genre.

The long tradition of easel painting, with its well-understood conventions, made innovation easier. Whereas

Luis Meléndez's *Still Life with Oranges and Walnuts* of 1772 (page 239) stresses the volumetric geometry and surface texture of objects disposed in three-dimensional space—the traditional concerns of still life—much of the interest in Pablo Picasso's 1914 painting of coloured and textured flat shapes, arranged on the surface of the canvas, comes from suddenly recognising the fragmented constituents of *Fruit Dish, Bottle, and Violin* (page 279). If the illusion of reality, now a well-worn convention, pleases, so does the reminder of the artfulness of art, its autonomy from external reality. Illusionism and artistic autonomy are both wittily demonstrated by Jean-Auguste-Dominique Ingres in his monumental portrait *Madame Moitessier* of 1856 (page 252). The forms and textures of the lady's clothes, jewellery, and skin, the overstuffed sofa on which she sits, and the ornaments behind her are all depicted with quasi-obsessive fidelity, but Ingres also introduced an optical impossibility: Madame Moitessier's profile is shown in a mirror that, in reality, could only reflect the back of her head.

Increasingly, art throughout the eighteenth and nineteenth centuries played with references to earlier art, not only to tradition and conventions in general but to specific works. Reynolds's *Lady Cockburn and Her Three Eldest Sons* of 1773 (page 227) gains resonance by echoing an allegory of Charity by van Dyck. Much of the

poignancy of Joseph Mallord William Turner's *The Fighting "Temeraire" Tugged to Her Last Berth to Be Broken Up, 1838* (page 256) comes from its resemblance to the heroic Embarkations (page 189) of Claude. Pierre Puvis de Chavannes's *Beheading of Saint John the Baptist* of around 1869 (page 258), with its matte colours and flattened forms, is meant to evoke the solemnity of Italian fourteenth-century frescoes. Constable looked to Rubens, Sir Thomas Lawrence to Titian and van Dyck; Paul Cézanne's *Bathers* (page 273) aspire to the serene sensuality of Venetian Renaissance nymphs; Matisse modified his *Portrait of Greta Moll* (page 278) after studying a Veronese in the Louvre. The "art of the museums" does not spell the end of art, but makes possible its perennial renewal.

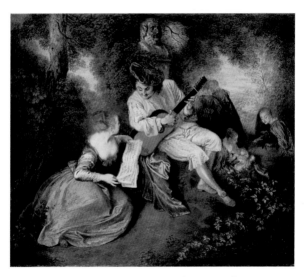

JEAN-ANTOINE WATTEAU (1684–1721).
The Scale of Love, 1715–18.
Oil on canvas, 20 x 23½ in. (50.8 x 59.7 cm).

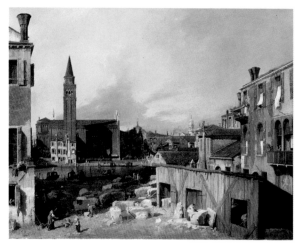

CANALETTO (1697–1768).
Venice: Campo San Vidal and Santa Maria della Carità
("The Stonemason's Yard"), 1726–30.
Oil on canvas, 48¾ x 64⅛ in. (123.8 x 162.9 cm).

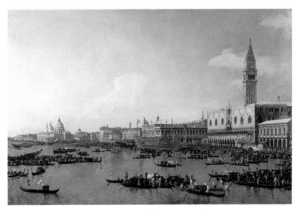

CANALETTO (1697–1768).
Venice: The Basin of San Marco on Ascension Day, c. 1740.
Oil on canvas, 48 x 72 in. (121.9 x 182.8 cm).

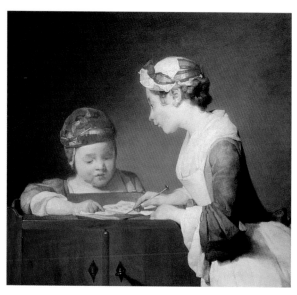

Jean-Siméon Chardin (1699–1779).
The Young Schoolmistress, probably 1735–36.
Oil on canvas, 24¼ x 26¼ in. (61.6 x 66.7 cm).

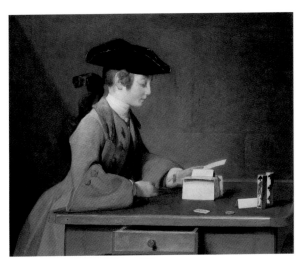

JEAN-SIMÉON CHARDIN (1699–1779).
The House of Cards, c. 1736–37.
Oil on canvas, 23¾ x 28¼ in. (60.3 x 71.8 cm).

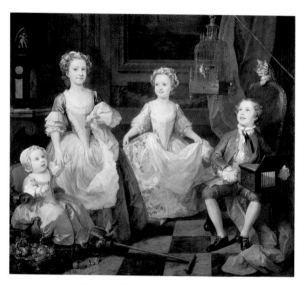

WILLIAM HOGARTH (1697–1764).
The Graham Children, 1742.
Oil on canvas, 63¼ x 71¼ in. (160.5 x 181 cm).

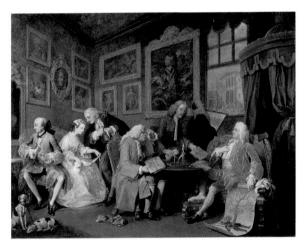

WILLIAM HOGARTH (1697–1764).
Marriage à la Mode: I, The Marriage Contract, before 1743.
Oil on canvas, 27½ x 35¾ in. (69.9 x 90.8 cm).

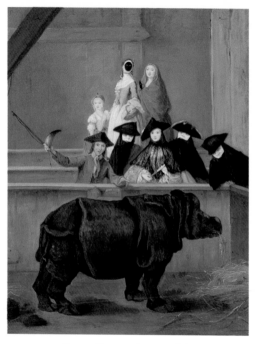

PIETRO LONGHI (1701–1785).
Exhibition of a Rhinoceros at Venice, probably 1751.
Oil on canvas, 23¾ x 18½ in. (60.4 x 47 cm).

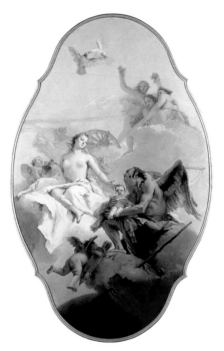

GIOVANNI BATTISTA TIEPOLO (1696–1770).
An Allegory with Venus and Time, c. 1754–58.
Oil on canvas, 115 x 75 in. (292 x 190.4 cm).

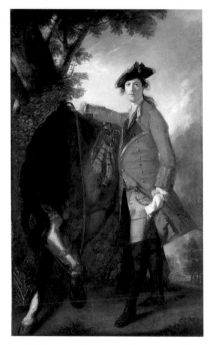

Sir Joshua Reynolds (1723–1792).
Captain Robert Orme, 1756.
Oil on canvas, 94½ x 58 in. (240 x 147.3 cm).

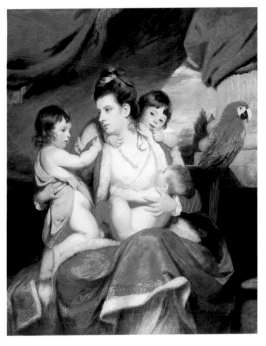

SIR JOSHUA REYNOLDS (1723–1792).
Lady Cockburn and Her Three Eldest Sons, 1773.
Oil on canvas, 55¾ x 44½ in. (141.6 x 113 cm).

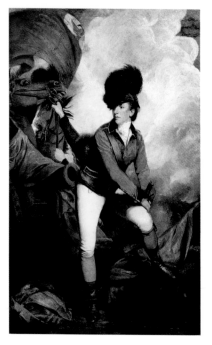

SIR JOSHUA REYNOLDS (1723–1792).
Colonel Banastre Tarleton, 1782.
Oil on canvas, 93 x 57¼ in. (236.2 x 145.4 cm).

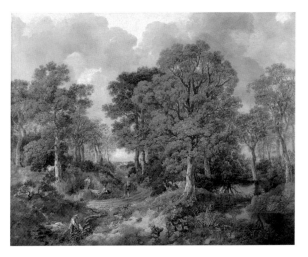

THOMAS GAINSBOROUGH (1727–1788).
Gainsborough's Forest ("Cornard Wood"), c. 1748.
Oil on canvas, 48 x 61 in. (121.9 x 154.9 cm).

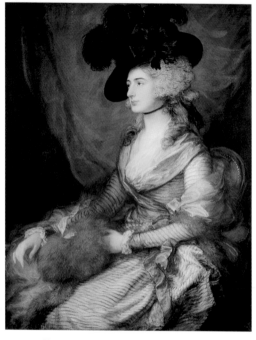

THOMAS GAINSBOROUGH (1727–1788).
Mrs. Siddons, c. 1783–85.
Oil on canvas, 49¾ x 39¼ in. (126.4 x 99.7 cm).

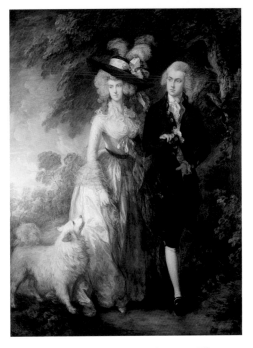

Thomas Gainsborough (1727–1788).
Mr. and Mrs. William Hallett ("The Morning Walk"), c. 1785.
Oil on canvas, 93 x 70½ in. (236.2 x 179.1 cm).

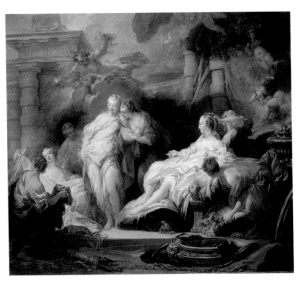

JEAN-HONORÉ FRAGONARD (1732–1806).
Psyche Showing Her Sisters Her Gifts from Cupid, 1753.
Oil on canvas, 66¼ x 75¾ in. (168.3 x 192.4 cm).

FRANÇOIS-HUBERT DROUAIS (1727–1775).
Madame de Pompadour, 1763–64.
Oil on canvas, 85½ x 61¾ in. (217 x 156.8 cm).

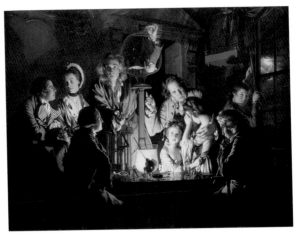

JOSEPH WRIGHT OF DERBY (1734–1797).
An Experiment on a Bird in the Air Pump, 1768.
Oil on canvas, 72 x 96 in. (182.9 x 243.9 cm).

JOSEPH WRIGHT OF DERBY (1734–1797).
Mr. and Mrs. Thomas Coltman, c. 1770–72.
Oil on canvas, 50 x 40 in. (127 x 101.6 cm).

235

GEORGE STUBBS (1724–1806).
The Milbanke and Melbourne Families, c. 1769.
Oil on canvas, 38¼ x 58¾ in. (97.2 x 149.3 cm).

Francesco Guardi (1712–1793).
An Architectural Caprice, probably 1770s.
Oil on canvas, 8¾ x 6¾ in. (22.1 x 17.2 cm).

FRANCESCO GUARDI (1712–1793).
View of the Venetian Lagoon with the Tower of Malghera,
probably 1770s. Oil on wood, 8⅜ x 16¼ in. (21.3 x 41.3 cm).

Luis Meléndez (1716–1780).
Still Life with Oranges and Walnuts, 1772.
Oil on canvas, 24 x 32 in. (61 x 81.3 cm).

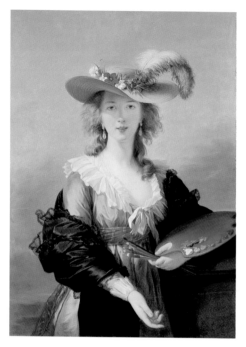

ELIZABETH LOUISE VIGÉE LE BRUN (1755–1842).
Self-Portrait in a Straw Hat, after 1782.
Oil on canvas, 38½ x 27¾ in. (97.8 x 70.5 cm).

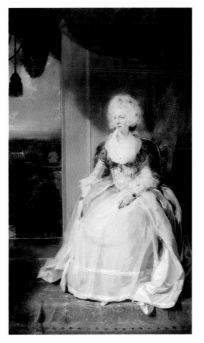

SIR THOMAS LAWRENCE (1769–1830).
Queen Charlotte, 1789–90.
Oil on canvas, 94¼ x 58 in. (239.4 x 147.3 cm).

241

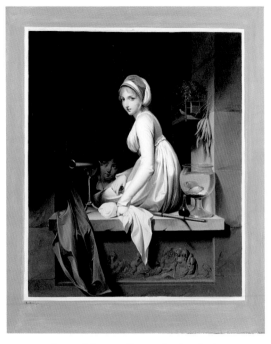

Louis-Léopold Boilly (1761–1845).
A Girl at a Window, after 1799.
Oil on canvas, 21¾ x 18 in. (55.2 x 45.7 cm).

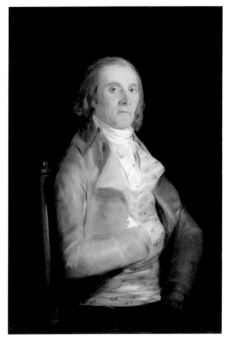

FRANCISCO DE GOYA (1746–1828).
Don Andrés del Peral, before 1798.
Oil on poplar, 37⅜ x 25⅞ in. (95 x 65.7 cm).

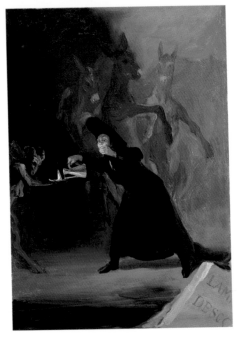

FRANCISCO DE GOYA (1746–1828).
A Scene from "El Hechizado por Fuerza"
("The Forcibly Bewitched"), 1798.
Oil on canvas, 16¾ x 12⅛ in. (42.5 x 30.8 cm).

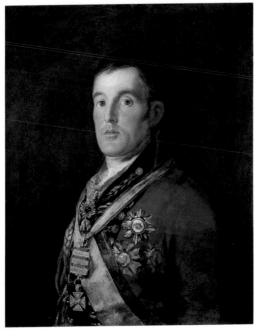

FRANCISCO DE GOYA (1746–1828).
The Duke of Wellington, 1812–14.
Oil on mahogany, 25¼ x 20⅝ in. (64.3 x 52.4 cm).

JACQUES-LOUIS DAVID (1748–1825).
Portrait of Jacobus Blauw, 1795.
Oil on canvas, 36¼ x 28¾ in. (92 x 73 cm).

JACQUES-LOUIS DAVID (1748–1825).
Portrait of the Vicomtesse Vilain XIIII and Her Daughter, 1816.
Oil on canvas, 37⅜ x 29⅞ in. (95 x 76 cm).

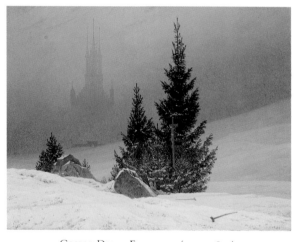

CASPAR DAVID FRIEDRICH (1774–1840).
Winter Landscape, probably 1811.
Oil on canvas, 12¾ x 17¾ in. (32.5 x 45 cm).

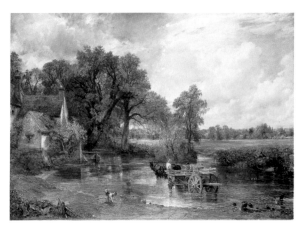

JOHN CONSTABLE (1776–1837).
The Hay-Wain, 1821.
Oil on canvas, 50¼ x 73 in. (130.2 x 185.4 cm).

JOHN CONSTABLE (1776–1837).
Salisbury Cathedral and Archdeacon Fisher's House,
from the River Avon, probably 1821.
Oil on canvas, 20¾ x 30¼ in. (52.7 x 76.8 cm).

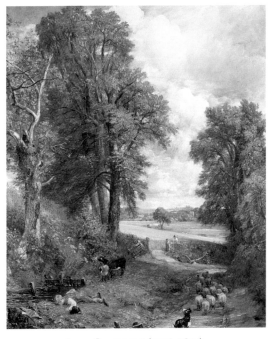

JOHN CONSTABLE (1776–1837).
The Cornfield, 1826.
Oil on canvas, 56¼ x 48 in. (142.9 x 121.9 cm).

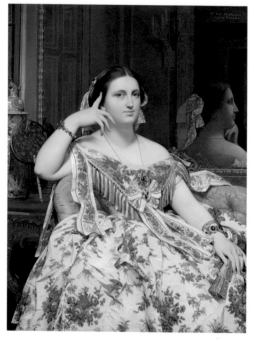

JEAN–AUGUSTE–DOMINIQUE INGRES (1780–1867).
Madame Moitessier, 1856.
Oil on canvas, 47¼ x 36¼ in. (120 x 92.1 cm).

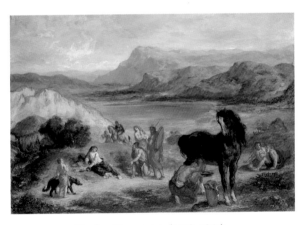

EUGÈNE DELACROIX (1798–1863).
Ovid among the Scythians, 1859.
Oil on canvas, 34½ x 51¼ in. (87.6 x 130.2 cm).

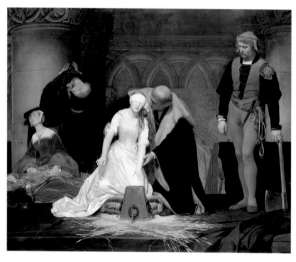

PAUL DELAROCHE (1795–1856).
The Execution of Lady Jane Grey, 1833.
Oil on canvas, 96⅞ x 117 in. (246 x 297 cm).

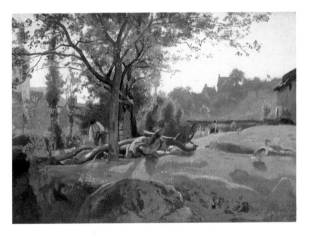

Jean-Baptiste-Camille Corot (1796–1875).
Peasants under the Trees at Dawn, c. 1840–45.
Oil on canvas, 11⅛ x 15⅝ in. (28.2 x 39.7 cm).

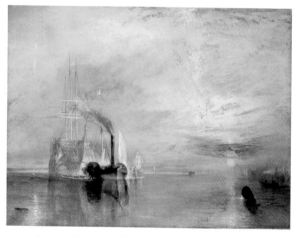

JOSEPH MALLORD WILLIAM TURNER (1775–1851).
The Fighting "Temeraire" Tugged to Her Last Berth
to Be Broken Up, 1838, 1838–39.
Oil on canvas, 35¾ x 48 in. (90.8 x 121.9 cm).

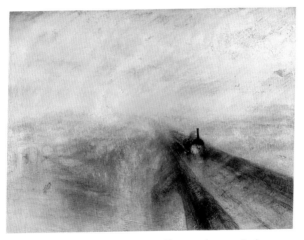

JOSEPH MALLORD WILLIAM TURNER (1775–1851).
Rain, Steam, and Speed—The Great Western Railway,
before 1844. Oil on canvas, 35¾ x 48 in. (90.8 x 121.9 cm).

PIERRE PUVIS DE CHAVANNES (1824–1898).
The Beheading of Saint John the Baptist, c. 1869.
Oil on canvas, 94½ x 124½ in. (240 x 316.2 cm).

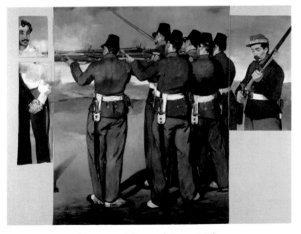

EDOUARD MANET (1832–1883).
The Execution of Maximilian, c. 1867–68. Oil on canvas (four
fragments on a single support), 76 x 111¾ in. (193 x 284 cm).

EDOUARD MANET (1832–1883).
Eva Gonzalès, 1870.
Oil on canvas, 75¼ x 52½ in. (191.1 x 133.4 cm)

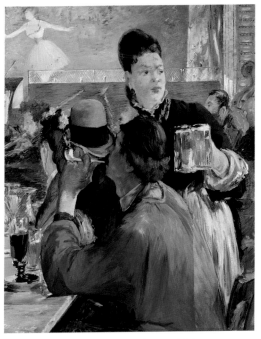

EDOUARD MANET (1832–1883).
Corner of a Café-Concert, probably 1878–80.
Oil on canvas, 38¼ x 30½ in. (97.1 x 77.5 cm).

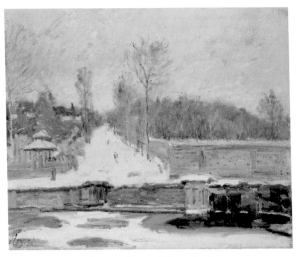

ALFRED SISLEY (1839–1899).
The Watering Place at Marly-le-Roi, probably 1875.
Oil on canvas, 19½ x 25¾ in. (49.5 x 65.4 cm).

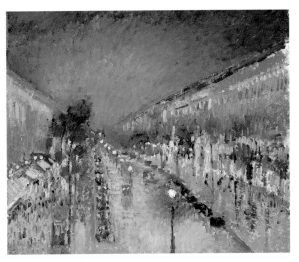

CAMILLE PISSARRO (1830–1903).
The Boulevard Montmartre at Night, 1897.
Oil on canvas, 21 x 25½ in. (53.3 x 64.8 cm).

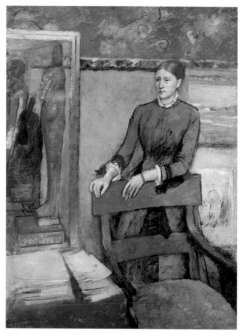

EDGAR DEGAS (1834–1917).
Hélène Rouart in Her Father's Study, c. 1886.
Oil on canvas, 63⅜ x 46¼ in. (161 x 120 cm).

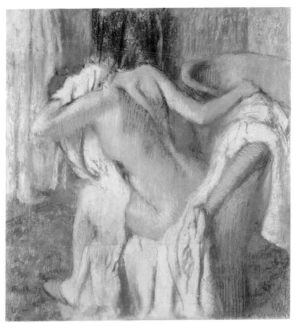

EDGAR DEGAS (1834–1917).
After the Bath, Woman Drying Herself, probably 1888–92.
Pastel on paper mounted on cardboard,
40⅞ x 38¾ in. (103.8 x 98.4 cm).

PIERRE-AUGUSTE RENOIR (1841–1919).
Boating on the Seine, c. 1879–80.
Oil on canvas, 28 x 36¼ in. (71 x 92 cm).

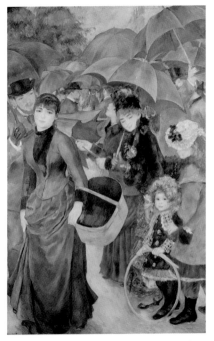

PIERRE-AUGUSTE RENOIR (1841–1919).
The Umbrellas, c. 1881–86.
Oil on canvas, 71 x 45¼ in. (180.3 x 114.9 cm).

CLAUDE MONET (1840–1926).
Bathers at La Grenouillère, 1869.
Oil on canvas, 28¾ x 36¼ in. (73 x 92 cm).

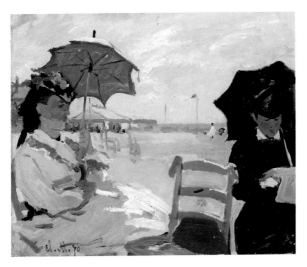

CLAUDE MONET (1840–1926).
The Beach at Trouville, 1870.
Oil on canvas, 14¾ x 18 in. (37.5 x 45.7 cm).

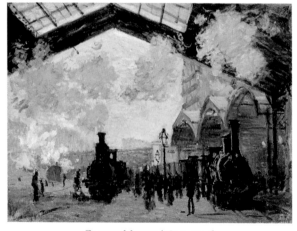

CLAUDE MONET (1840–1926).
The Gare St.-Lazare, 1877.
Oil on canvas, 21⅜ x 29 in. (54.3 x 73.6 cm).

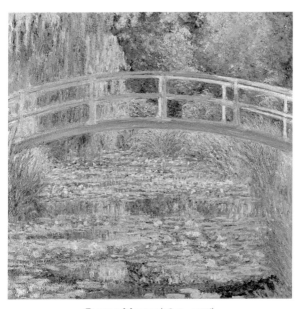

CLAUDE MONET (1840–1926).
The Water-Lily Pond, 1899.
Oil on canvas, 34¾ x 36⅝ in. (88.3 x 93.1 cm).

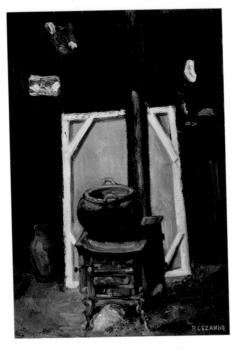

PAUL CÉZANNE (1839–1906).
The Stove in the Studio, probably 1865–70.
Oil on canvas, 16⅛ x 11¾ in. (41 x 30 cm).

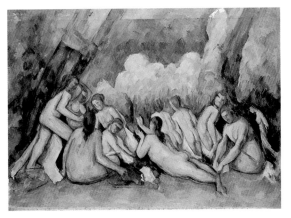

PAUL CÉZANNE (1839–1906).
Bathers (Les Grandes Baigneuses), c. 1900–1906.
Oil on canvas, 50⅛ x 78½ in. (127.2 x 196.1 cm).

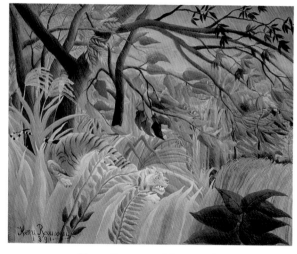

HENRI ROUSSEAU (1844–1910).
Tiger in a Tropical Storm (Surprised!), 1891.
Oil on canvas, 51⅛ x 63¾ in. (129.8 x 161.9 cm).

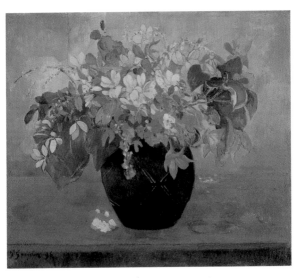

PAUL GAUGUIN (1848–1903).
A Vase of Flowers, 1896.
Oil on canvas, 25¼ x 29⅛ in. (64 x 74 cm).

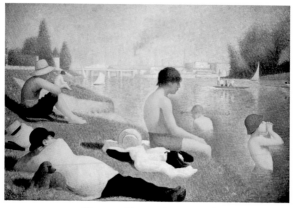

GEORGES SEURAT (1859–1891).
Bathers at Asnières, 1884.
Oil on canvas, 79⅛ x 118⅛ in. (201 x 300 cm).

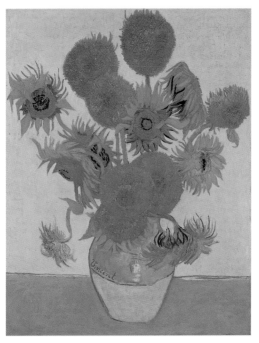

VINCENT VAN GOGH (1853–1890).
Sunflowers, 1888.
Oil on canvas, 36¼ x 28¾ in. (92.1 x 73 cm).

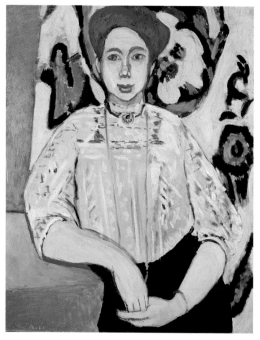

HENRI MATISSE (1869–1954).
Portrait of Greta Moll, 1908. Oil on canvas, 36⅝ x 29 in.
(93 x 73.5 cm). On loan to the Tate Gallery since 1997.

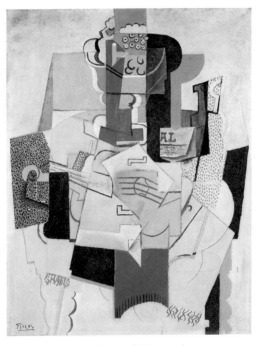

PABLO PICASSO (1881–1973).
Fruit Dish, Bottle and Violin, 1914. Oil on canvas, 36¼ x 28¾ in.
(92 x 73 cm). On loan to the Tate Gallery since 1997.

INDEX OF ILLUSTRATIONS

283

285

EDITOR, National Gallery: Jan Green PRODUCTION EDITOR: Meredith Wolf
EDITOR, ABBEVILLE: Nancy Grubb PRODUCTION MANAGER: Richard Thomas

First hardcover edition
15 14 13 12 11 10 9 8 7 6 5

Library of Congress Cataloging-in-Publication Data
National Gallery (Great Britain)
 Treasures of the National Gallery, London / introduction by
Neil MacGregor ; text by Erika Langmuir.
 p. cm.
 "A tiny folio."
 Includes index.
 ISBN 0-7892-0148-8 (pb); 0-7892-0482-7 (hc)
 1. Painting—England—London—Catalogs. 2. National Gallery
(Great Britain)—Catalogs. I. Langmuir, Erika. II. Title.
N1070.A698 1996
708.2'1'32—dc20 96-3919

SELECTED **TINY FOLIOS**™ FROM ABBEVILLE PRESS

American Impressionism 0-7892-0612-9 ▪ $11.95

Angels 0-7892-0403-7 ▪ $11.95

Antonio Gaudí: Master Architect 0-7892-0690-0 ▪ $11.95

The Great Book of French Impressionism 0-7892-0405-3 ▪ $11.95

Norman Rockwell: 332 Magazine Covers 0-7892-0409-6 ▪ $11.95

Edgar Degas 0-7892-0201-8 ▪ $11.95

Treasures of British Art: Tate Gallery 0-7892-0541-6 ▪ $11.95

Treasures of Impressionism and Post-Impressionism: National Gallery of Art 0-7892-0208-5 ▪ $11.95

Treasures of the Louvre 0-7892-0406-1 ▪ $11.95

Treasures of the Musée d'Orsay 0-7892-0408-8 ▪ $11.95

Treasures of the Musée Picasso 0-7892-0576-9 ▪ $11.95

Treasures of the Museum of Fine Arts, Boston 0-7892-0506-8 ▪ $11.95

Treasures of the National Museum of the American Indian 0-7892-0105-4 ▪ $11.95

Treasures of 19th- and 20th-Century Painting: The Art Institute of Chicago 0-7892-0402-9 ▪ $11.95

Treasures of the Prado 0-7892-0490-8 ▪ $11.95

Treasures of the Uffizi 0-7892-0575-0 ▪ $11.95

Women Artists: The National Museum of Women in the Arts 0-7892-0411-8 ▪ $11.95